Billings

Greetings! The author hopes you enjoy this historical postcard look at Billings, Montana. (ASM.)

FRONT COVER: By the late 1950s, the old Yellowstone Courthouse was becoming overcrowded and unsafe. The new $1.5-million building was completed in 1958, just north of the old courthouse. Before the wrecking ball demolished the old courthouse in 1958, the two buildings sat side-by-side for a few months. Today there is a park and veteran memorial wall where the once stately building stood. (KFR.)

BACK COVER: This rare view depicts a 1918 World War I rally parade heading east along the 2800 block of Montana Avenue. There is a man carrying a fancy banner that reads Hart Albin Company followed by 10 well-dressed men carrying a large American flag. The businesses from left to right are the Custer Hardware, David Roe Dry Goods, Yale Hotel, Colonial Café, Mowre Cigar and Billiards Store, and F. E. Crosby Studio, which took this photograph. (FEC.)

POSTCARD HISTORY SERIES

Billings

James M. Reich

ARCADIA
PUBLISHING

Published by Arcadia Publishing
Charleston, South Carolina

Printed in the United States of America

Library of Congress Control Number: 2009921923

For all general information contact Arcadia Publishing at:
Telephone 843-853-2070
Fax 843-853-0044
E-mail sales@arcadiapublishing.com
For customer service and orders:
Toll-Free 1-888-313-2665

Visit us on the Internet at www.arcadiapublishing.com

CONTENTS

ACKNOWLEDGMENTS

After 20 years of collecting Billings postcards, I am finally able to take my collection and love of history to the next level. It was an honor and a privilege to have been chosen by Arcadia Publishing to write a Billings history book. My editor, John Poultney, gave me solid guidance through this new and exciting experience; I also want to thank the scanning and layout department for the great job they did in putting this book together. Thanks to my family and friends for giving me friendship and historical insight in the writing process and to the Parmly Billings Library for allowing me to use the vertical files and scrapbooks. Deep appreciation goes to Joyce Curry, Brittany Critelli, and Diversified Management Assistance for transcription assistance. Thanks to my mother, for this project would not have been possible without her love and guidance. Lastly, I would like to thank all the photographers who helped preserve a small piece of Billings history through postcards, without which this book would not be possible.

All images herein are from James M. Reich's private collection of Billings ephemera; many are one-of-a-kind real-photo cards or other printed cards with no recorded publisher. The following abbreviations are shown at the end of each caption to reference applicable publishers: Kenneth F. Roahn (KFR); Ralph Doubleday (RD); Jerome Kohn Company (JKC); Charles Chapple (CC); O. C. Overn (OCO); Montana Publishing Company (MPC); Merchants Film Service, Winoma, Minnesota (MFS); Holmboe and White, New Salem, North Dakota (HW); Cohn Brothers, Butte, Montana (CB); RWG (RWG); Frank E. Crosby (FEC); R. F. OuTeault (RFOT): Withham Studio (WS): Lawhead (L); J. L. Robbins Company, Spokane, Washington (JLRC): Wesley Anders, Inc., Baker, Oregon (WAI); A. J. Hedrix (AJH): Post Office News Stand (PONS); Lutz, Mandan, North Dakota (LUTZ); Wright Advertising Special Company (WASC); the Fair (Fair); Western Image, Inc. (WII); Kaeser and Blair, Inc., Cincinnati, Ohio (KBI); Ellis Postcard Company, Arlington, Washington (EPC); Bloom Brothers Publishers, Minneapolis, Minnesota (BBP); John H. Petek (JJP); National Press Chicago (NCP); Boyd Studio (BS); A. H. Company (AHC); American Import Company, Minneapolis, Minnesota (AIC); Alfred Baumgartner (AB); E. C. Kropp Company, Milwaukee, Wisconsin (ECKK); Robert Aerne, Portland, Oregon (RA); Clear-Vue-Willens, Chicago (CVW); George J. Lass (GJL); Sturm (S); the Colonial Café (TCC); MWM, Aurora, Missouri (MWM); Robbins Tillquist, Spokane, Washington (RT); Dexter Press, Pearl River, New York (DP); A. S. Meeker, New York (ASM); and Tom Jones, Cincinnati, Ohio (TJ).

INTRODUCTION

For over 125 years, Billings has been coping with its ever-growing population. From a small tent town in 1882 to the large thriving town it is today, Billings is recognized as a trade center, transportation hub, banking center, and a medical and educational center. Also very important is agriculture, livestock, communication, and sugar beet and oil refining plants. All these areas of early Billings's life were recorded on postcards.

This book contains 226 postcards, from one-of-a-kind to those that were massed produced by the thousands. The messages on many of the postcards provide important information relative to the image, the time, or the place. Many postcards were bought and sent by passengers of trains that tell tales of long layovers, missing their hometowns, and adventures around Billings. In the age of early automobiles, messages tell stories of bad roads and seeing family for the first time in many years. Some cards sent from Billings tell of a rough-and-tumble trip through Yellowstone Park. Several of the cards paint a picture of hardships during the dust bowl years. Thousands of people came from rural Montana looking for work, only to find others looking for the same jobs. Postcards also tell a story of an ever-changing face of the downtown business district.

Billings may well be the perfect example of a town whose coming of age paralleled the golden age of picture postcards. It is well documented by the hundreds of cards in the marketplace. The large amount of cards printed through the years reveals a community in all its ever-changing complexities, business buildings, churches, schools, houses, parks, parades, fairs, and thoroughfares. When all the postcards in this book are put together, the story of early Billings can be better understood.

In 1900, Billings had a population of 3,221, up from 836, and was finally climbing out of the depression of 1893. This book presents an overview of the history of Billings from the 1890s through the oil boom of the 1950s. Much of Billings's early growth was spurred on by the early chamber of commerce, which promoted the city at every level. The larger population meant that a larger and more permanent infrastructure had to be built. In 1903, the first permanent city hall was built, followed by a new Yellowstone County Courthouse two years later. During the first 20 years of the new century, eight schools were built along with numerous churches. In 1913, a new federal building was constructed, as was a streetcar system. By 1910, Billings's population had reached 10,031; in another decade, it was 15,100.

During the 1920s, the growth of Billings slowed as a result of the dust bowl years. Residents were no longer relegated to one-of-a-kind stores; shoppers had a wide range of businesses to choose from. In 1928, Billings's first radio station started broadcasting radio programs, bringing families close together. In 1927, East Montana Normal School opened, and the campus was

built in 1936 under the shadow of the Rims. It was also at this time that the Yale Oil Company started refining oil near the present fairgrounds. In 1940, Billings had a population of 23,261 and rose to 31,834 in 1950. By the end of the 1930s, Billings had a new high school on Grand Avenue and a new city hall had begun. In 1940, the Northern Hotel burned to the ground only to be rebuilt within a year. During the 1950s, Billings benefited from the oil boom in which regional oil offices were located in the city. During this period, Billings was experiencing a rapid growth in housing and businesses west of the city.

The 226 postcards detailed in this book tell the story of how Billings became the premiere shopping, shipping, and industry center in Montana. It is amazing that these little pieces of history have survived such a long time. It is little wonder that postcard collectors sometimes pay large amounts for a rare find. After reading this book, the reader is invited to explore Billings and find out more about its rich history.

One

BUILDINGS, STREET SCENES

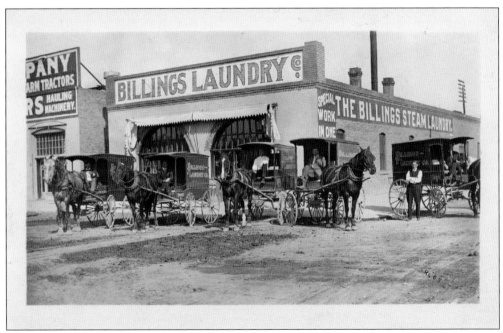

Started in 1906, the Billings Laundry had very humble beginnings with only two delivery wagons. By the 1940s, they had grown to be the largest laundry between Minneapolis and Spokane. F. C. Cline was the founder of the Billings Laundry. Many downtown workers went to lunch and went home at the ringing of the loud steam whistle of the Billings Laundry. The postcard shows the Billings Laundry in about 1912 with its five wagons.

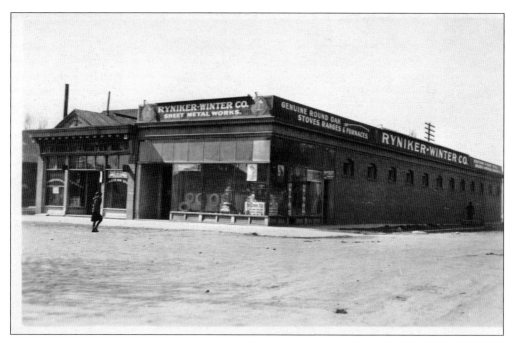

Harold Winter and Walter Ryniker moved to Billings in 1907. In 1908, they bought a local tin shop and established the business of Ryniker Winter Sheet Metal Works, located at 122–124 North Twenty-fifth Street. In 1915, the two partners opened a hardware store under the name Ryniker Winter Hardware. By 1921, they had 47 employees working for them. In the late 1930s, the two businessmen went their separate ways. Winter took the hardware store and Ryniker the sheet metal business. The card below shows an interior view of the sheet metal workroom.

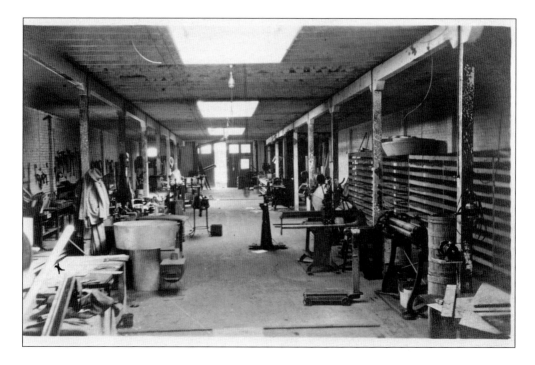

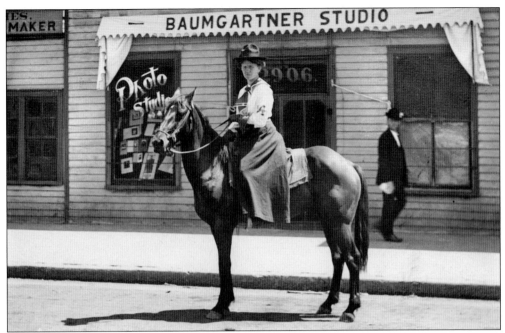

Alfred Baumgartner (1875–1947) moved to Billings, by an invitation of the Yegens, to open a photographic studio. The studio opened in 1906 with much success but closed after a few years. In 1918, Alfred's son-in-law John Green reopened the studio, which was located at 2820 First Avenue North. Peggy McGrath, mounted on the horse, was an employee at Baumgartner's first studio at 2906 Minnesota Avenue. (BS.)

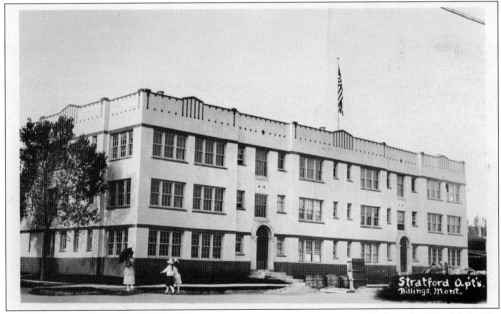

In the early 1920s, the Stratford Apartments were built at 2815 Sixth Avenue North. At the time, the apartment building was the largest in Billings. Over the years, ivy vines have almost completely covered the front of the building. Streeter Brothers (real estate and insurance) company is located on the lower floor.

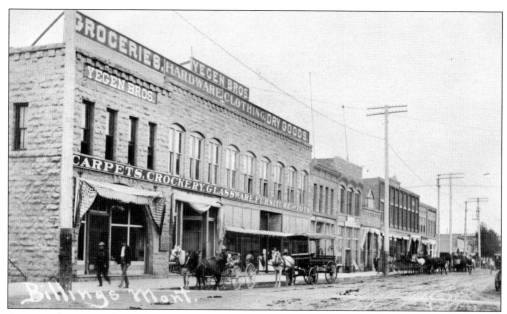

Among the most familiar names in Yellowstone County are the Yegens. Peter Yegen (1860–1937) and Christian Yegen (1857–1935) arrived in 1882 and opened a small bakery on Minnesota Avenue. By the 1890s, the Yegens moved and expanded to include groceries, hardware, clothing, and dry goods. The postcard shows the Yegen Brothers department store on 2802–2808 Minnesota Avenue. In 1926, the Yegens sold their business to William Elliot, and it eventually became Elliot Furniture.

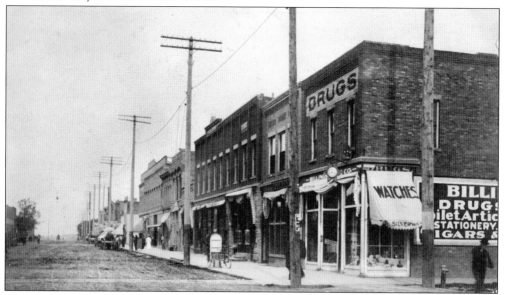

This 1906 postcard shows the 2800 block of Minnesota Avenue looking east. The building in the foreground housed the Billings Drug Company, owned by Charles S. Smith. The second story was occupied by Yegen Hall, which was used by several local unions and societies for meetings and offices. Wesley Hughes owned a plumbing business, in the second building from the left, for many years. The third building housed the Yegen Brothers Bank, which opened in 1900 and closed in 1925.

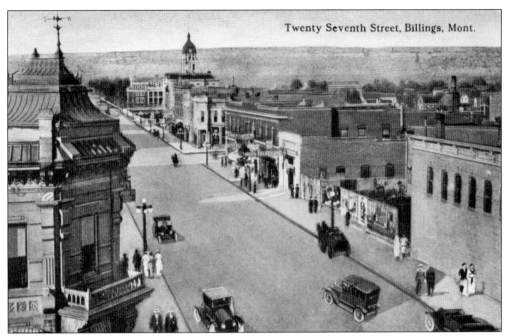

This aerial view was taken in 1922 from the Oliver Building. The photograph is looking north on Twenty-seventh Street toward the Rims. The highly detailed structure to the left was the Billings Gazette Building, original home of the First National Bank. In the center of the postcard is a small, single-story, white building, which housed the Mountain States Telephone and Telegraph Company, opened in 1914. (BBP.)

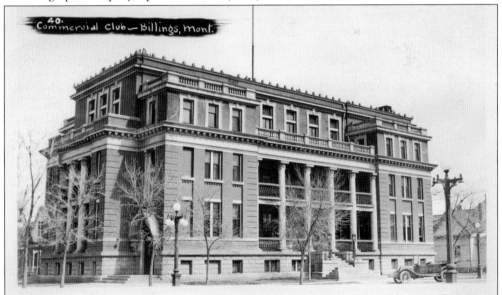

The Billings Elks (BPOE) Lodge No. 394 was chartered in 1898. In 1910, the Elks built their clubhouse at 301 North Twenty-seventh Street at the cost of $165,000. The Elks could not afford such an expensive structure, so in 1918, they sold the building to the Commercial Club. By 1971, the Commercial Club building was in sad shape and was saved from demolition. In 1972, the building was put on the National Register of Historic Places.

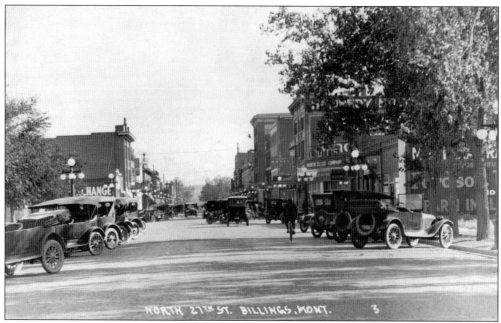

This postcard was taken in front of the old Yellowstone Courthouse looking south on Twenty-seventh Street. In the early days of automobiles, diagonal parking was the rule until parallel parking became favored. In the late 1990s, parts of downtown Billings once again became diagonal parking.

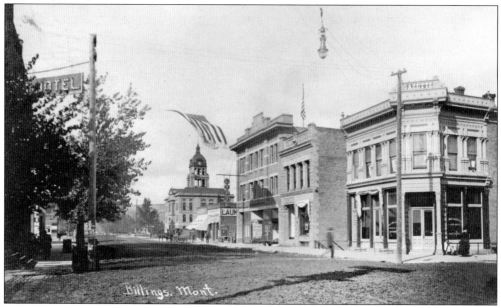

This photograph was taken in 1909 at the intersection of First Avenue North and Twenty-seventh Street looking north. The turn-of-the-century Gazette Building is on the corner followed by Rocky Mountain Bell Telephone Company and the Independent Order of Odd Fellows (IOOF). Many different societies held regular meetings in the meeting hall. The Rocky Mountain Bell Telephone Company opened an exchange in 1901 with 21 subscribers. By 1910, the number had risen to 784. Women manually operated the boards until 1931.

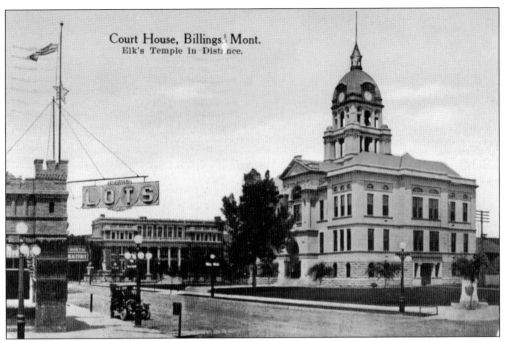

Court House, Billings, Mont.
Elk's Temple in Distance.

The trees along North Twenty-seventh Street and Second Avenue were mere saplings when the courthouse was photographed in 1913. It was built in 1905. The building with the castle-style parapet at the left housed the North Real Estate and Investment Company. The Chamber of Commerce Building, then the Elks Club, was built in 1910 (far background). (GJL.)

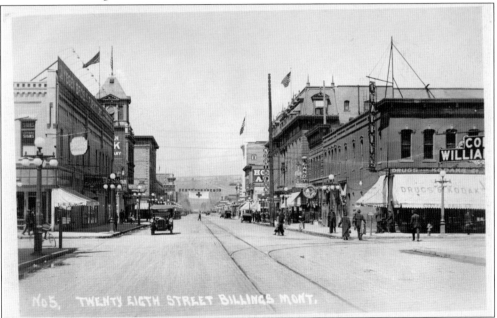

No 5, TWENTY EIGTH STREET BILLINGS MONT.

This is a view of Montana Avenue and Broadway looking north about 1918. Chapple Drug can be seen on the right followed by the original Northern Hotel. On the left side is a two-story building constructed in 1900 for Paul McCormick. It housed Keils Grocery, famous for their privately roasted coffee, for several years until they moved to Twenty-seventh Street.

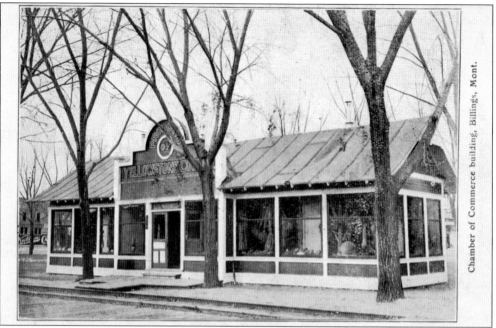

The mission of the Billings Chamber of Commerce (BCC) was to improve the community and conditions under which business is conducted. Passengers were persuaded to get off the train and visit the 1908 chamber building and view some of what the city had to offer. (MPC.)

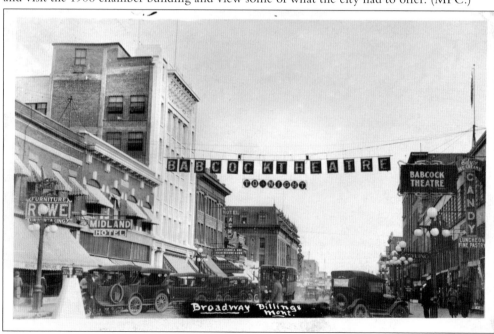

At the time this photograph was taken in the early 1920s, the 100 block of North Broadway was the main retail shopping center in Billings. The large letter sign overhead was an advertisement for the Babcock Theatre. By the late 1960s, a lot of the businesses were starting to move west as the city was growing, leaving this once busy block rather quiet. Starting in the 1990s, downtown Billings has experienced a regrowth in business opportunities.

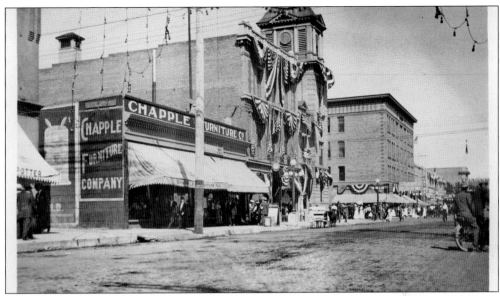

This postcard looks northwest on Broadway, about 1912, during a Fourth of July celebration. The streets have been decorated with electric lights (top of photograph), and city hall is covered with patriotic flags. Thomas Chapple opened his furniture store at 14 North Broadway in about 1905. He carried a large line of furniture, carpets, and crockery. Thomas was the younger brother of the Chapples who owned Chapple Drug across the street. He closed his store and moved to San Bernardino, California, in 1916. Soon after, the store closed and the building was turned into a movie theater, eventually becoming the Lyric in 1927.

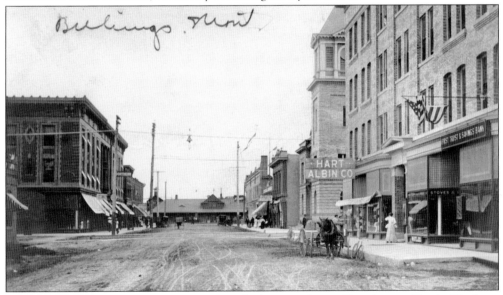

Here is a very quiet day in 1907 on Broadway looking south near First Avenue North. The large brick structure to the right is the Stapleton Building followed by the old city hall to the south. The three-story Northern Hotel, built in 1903, can be seen on the right side of the card. The 1893 depot was built across Broadway at the track, which can be seen in the background of the card. After the present depot was built in 1909, the old depot was moved and through traffic could flow north and south on Broadway.

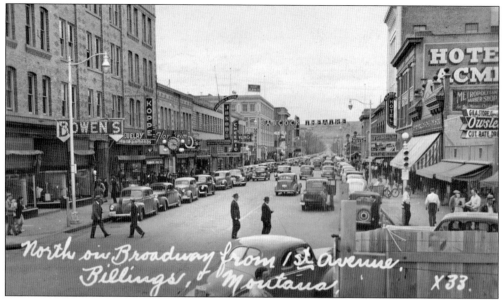

This busy street scene was taken looking north on Broadway during the early 1940s. The Stapleton on the left was the largest building on the block. It housed Bowen's men's clothing store and Koppe's Jewelry store, famous for diamonds, located at 106 North Broadway. O. L. Koppe opened the store in 1918 and was in business for over 65 years. Many longtime residents remember the beautiful clock that stood in front of Koppe's. After many years of service, the clock was sold to a businessman in Seattle, Washington. Jason's clothing store can be seen farther down the block.

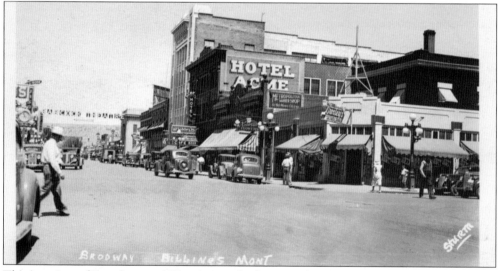

This is a view of Broadway and First Avenue looking north. The red two-story brick building (right) was constructed in the early 1900s as the Radmaker Hotel. By 1913, the lower floor was extended to the street and leased to businesses. The first business, in the facing corner, was the Bank of Billings in 1913. In 1945, the present Crystal Lounge started business at the corner location. Hopper's Floral was conducting business next door to the north. Joseph Hopper Sr. established his greenhouse on Lake Elmo Drive in 1905 and remained in business until the early 1990s. (S.)

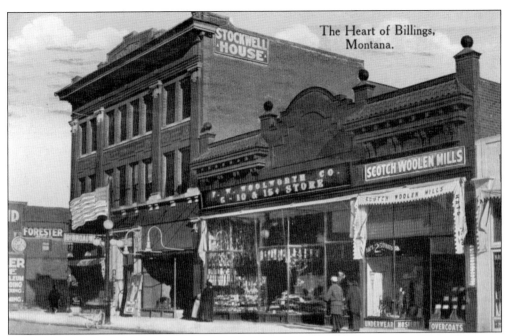

The Heart of Billings, Montana.

Above, this postcard shows an exterior view of the 5-and-10¢ F. W. Woolworth located at 107 North Broadway. The store was opened in about 1914 by F. B. Jacobs, manager. The three-story ACME Building was also constructed about 1914 and housed the Stockwell House Hotel, which eventually became the ACME Hotel. In 1914, the Broadway Theatre opened to the public at 113 North Broadway. The theater changed its name to Regent in 1916. Charles Forester had a jewelry store below the American flag.

In 1915, the Montana Power Company started to build at 115 North Broadway. The impressive five-story white-brick exterior was completed the following year. Montana Power Company had several hydroelectric dams that produced electricity for Billings and most of eastern Montana. The main office was located in Butte. Note the hanging marquee for the Regent Theatre next door, playing *The Silent Master* starring Bob Warwick. (CC.)

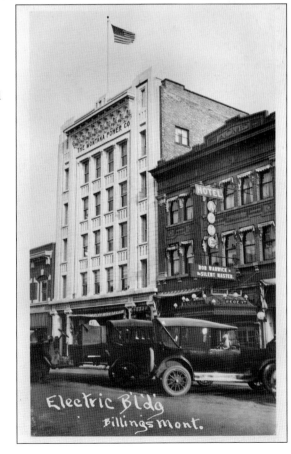

Electric Bld'g
Billings Mont.

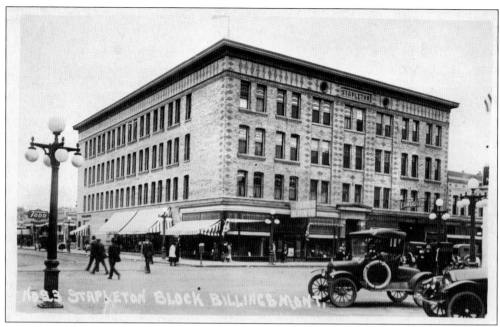

Constructed in the 1890s, the Cothron and Todd livery stable occupied the site of the future Stapleton Building. The four-story Stapleton was built in 1905 at 104 North Broadway. It housed two long-term businesses on the street level: Hart and Albin's and Koppe's Jewelry. In 2005, a group of investors started to renovate the 100-year-old building. The top two floors are being turned into condominiums.

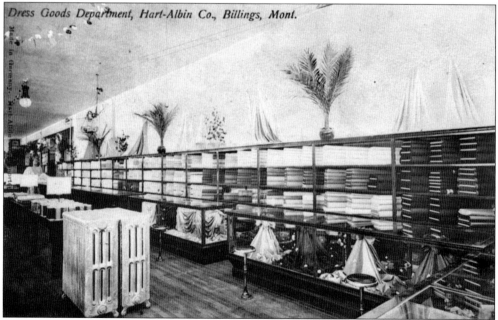

Hart and Albin moved into the Stapleton Building in 1905 from their old quarters on Montana Avenue. The interior view of the dress goods department in Hart and Albin's is pictured above in 1907. After a new Hart and Albin's building was constructed, the old store turned into Bowen's Man Store, which lasted until the early 1990s.

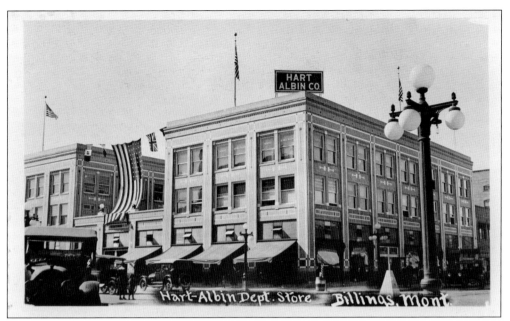

In 1917, Raymond S. Hart and Berthold Albin began construction of a three-story building on 200 North Broadway costing over $180,000. By 1938, Hart and Albin added a fourth floor, most of which was used by the Billings Clinic. In 1982, the center of the store was remodeled into a five-story atrium. The store closed in the mid-1990s.

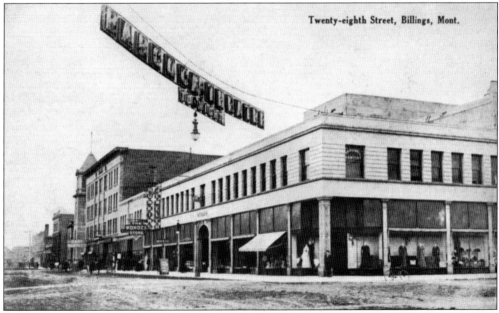

This 1910 postcard shows the Babcock Building located on Broadway and Second Avenue North. Soon after the original opera house burned in 1906, Albert L. Babcock (1851–1918) pledged to rebuild a new and grand theater building, which accommodated a new invention: moving pictures. A. L. Babcock served notice on this theater's patrons "that tobacco chewing and peanut eating is strictly prohibited and if you can not conform to the rules we do not want your presence." (PONS.)

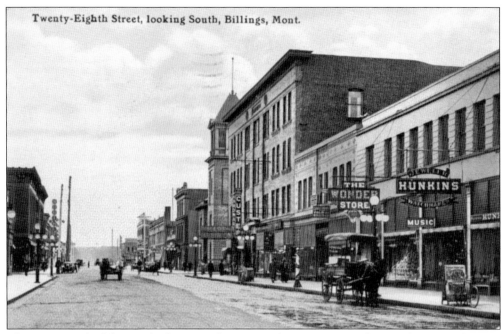

Twenty-Eighth Street, looking South, Billings, Mont.

This is a wonderful view looking south on Broadway in 1912. The Hunkins Jewelry and Wonder Store signs hang from the Babcock Building. The Wonder Store, open for less than 10 years, sold a wide range of items such as notions, dry goods, china, toys, and Billings souvenirs. The building next to the Wonder Store sign was used as the post office until it moved to the Twenty-sixth Street and First Avenue North location.

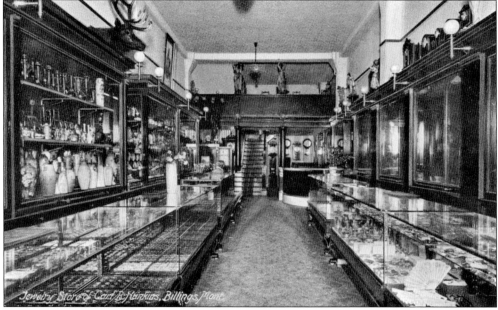

This is an interior view of the Hunkins Jewelry store located at 118 Broadway. Carl Hunkins opened his store in 1907, shortly after the Babcock Building was constructed. Hunkins carried a wide range of items for sale—jewelry, vases, decorative gift boxes, and clocks—and was advertised as a fine watchmaker. The jewelry store closed in the early 1920s. (AIC.)

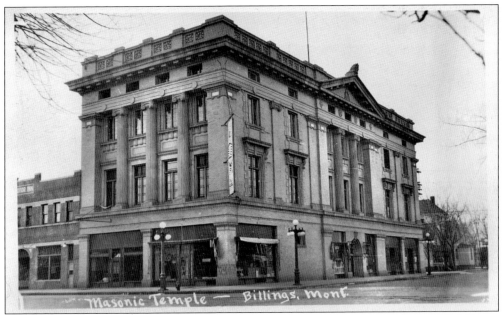

The first formal meeting of the Masonic Lodge was held on July 28, 1883, in the courthouse, a log cabin located where the post office is now situated, which burned in 1885. A resolution was adopted providing for the formation of the lodge to be known as Ashlor Lodge No. 29. The Masons of Billings met in several locations prior to building their own at Third Avenue North and Broadway. The building was completed in 1910. In the early 1950s, the Masons moved to their present location on Broadwater Avenue.

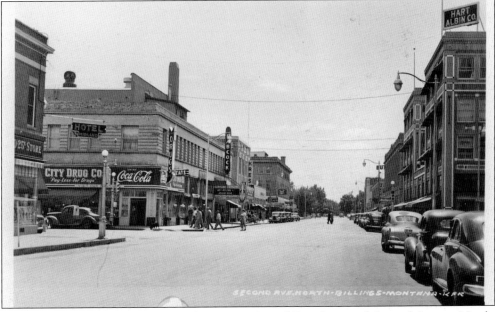

The postcard is looking west near the intersection of Broadway and Second Avenue North. On the left side of the card is the City Drug Company with its neon Coca-Cola sign. City Drug reportedly had the best soda fountain in town. Farther down the block was the Babcock Theatre, which was showing Roy Rogers in *Apache Rose*. (KFR.)

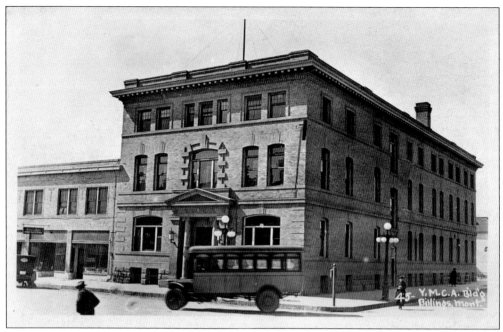

The YMCA building, located at 124 North Twenty-ninth Street, was constructed in 1908 at the cost of $85,000. It was used to shape the minds, bodies, and spirit of many boys and men. In the 1930s, the YMCA ran into financial difficulties and sold its building. After being remodeled, the old YMCA building was renamed the Treasure State. In the late 1940s, the YMCA reopened in the present location at 402 North Thirty-second Street.

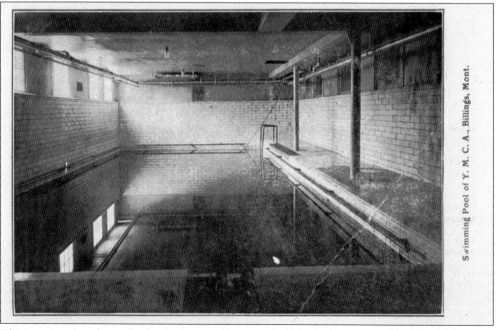

This interior view shows the first indoor pool in town, built in the basement of the YMCA in 1908. Members could swim year-round. The water was heated by boilers to a nice warm temperature. The pool was taken out when the YMCA sold the building in the 1930s. (MPC.)

The Odd Fellows building was constructed in about 1906 at 107 North Twenty-seventh Street. In that same year, W. M. Enright opened the Family Theatre on the street level with a vaudeville show and a motion picture entitled *Trip to the Moon*. The top two floors were reserved for secret society offices. The building was razed in the 1970s for the Wells Fargo Bank and parking garage. (BBP.)

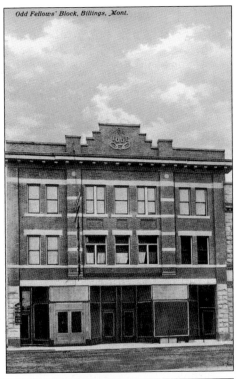

This photograph shows the aftermath of a large fire that gutted the Vaughn-Ragsdale clothing store and several other businesses on Twenty-ninth Street in 1932. The fire started on the north end of the block and traveled south, completely gutting the Vaughn-Ragsdale Building. Within three months, the Vaughn-Ragsdale clothing store reopened for business.

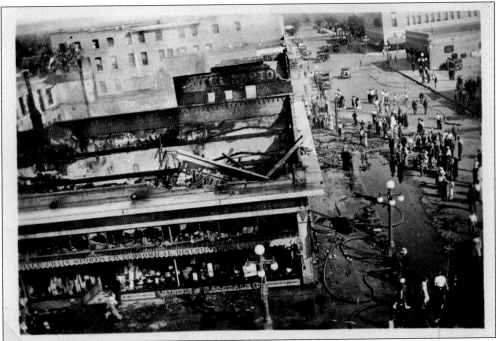

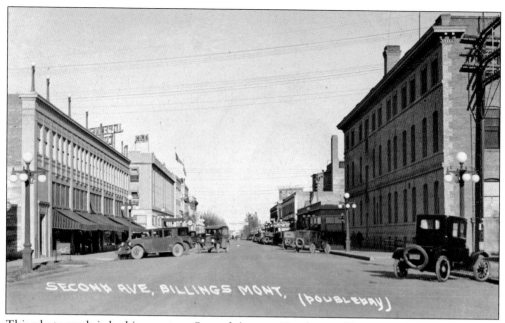

This photograph is looking east on Second Avenue North near Twenty-ninth Street in 1929. The building on the right is Treasure State with J. C. Penney's Hedden Building on the left. The message on the back is a testimonial to the road conditions in Montana: "Left Livingston this morning, it took six hours to drive 127 miles here. Roads were so bumpy and rough couldn't make any time, simply worn out. The roads jerk you to pieces." (RD.)

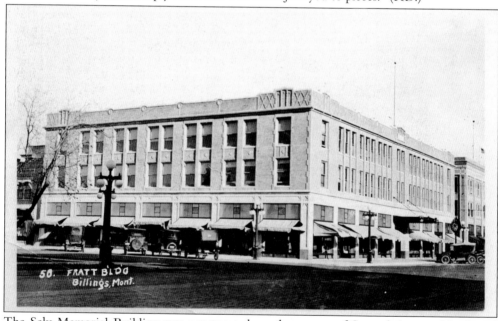

The Selv Memorial Building was constructed on the corner of Second Avenue North and Twenty-ninth Street on the original site of the Fratt house, built in 1899. In 1923, the Fratt building was finished and ready for leasing. Over the years, the two main tenants were the Jewelry Box, owned by Wallace Montague, and D. J. Coles. Coles carried a line of dry goods and ladies' ready-to-wear and was in the same location for over 65 years.

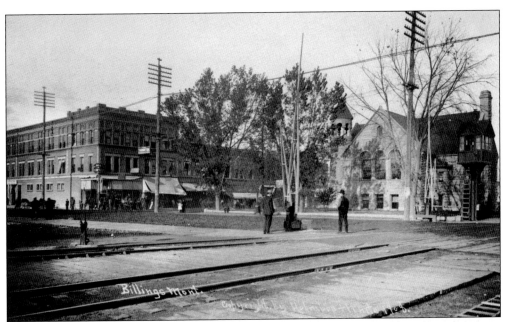

The 24 trains daily were a major concern to the citizens of Billings. In the early 1900s, the city built several watchtowers (far right) and manual train guards, such as the ones pictured here on Twenty-ninth Street, over the street to help prevent accidents. The old Parmly Billings Memorial Library (Western Heritage Center) is directly behind the watch tower. The towers were removed when better train guards were introduced in the 1930s. (HW.)

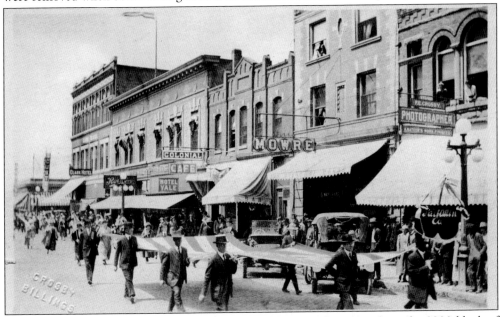

This rare view depicts a 1918 World War I rally parade heading east along the 2800 block of Montana Avenue. There is a man carrying a fancy banner that reads Hart and Albin Company followed by 10 well-dressed men carrying a large American flag. The businesses from left to right are the Custer Hardware, David Roe Dry Goods, Yale Hotel, Colonial Café, Mowre Cigar and Billiards Store, and F. E. Crosby Studio, which took this photograph. (FEC.)

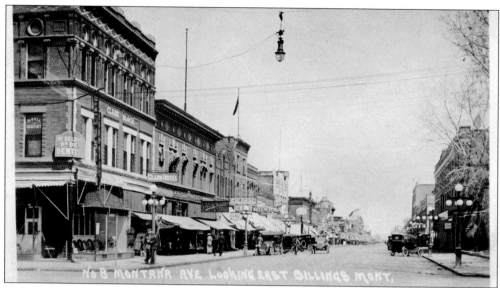

Not much of this once grand block is left. This photograph is looking east on Montana Avenue. The Clark Hotel (far left) was built in about 1903 and was torn down in 1968. The only buildings left on the block are the Fuller Hotel and the Losekamp Store next to the Clark Hotel. John D. Losekamp (1850–1913) came to Billings in 1882 and sold shoes in a tent. By 1885, he started selling a line of western wear. The above postcard shows his third building, which housed his Famous Outfitter clothing store at 2817 Montana Avenue. He helped establish Billings Polytechnic Institute, Rocky, in 1908. The Losekamp Music Hall, built in 1919, was named in his memory.

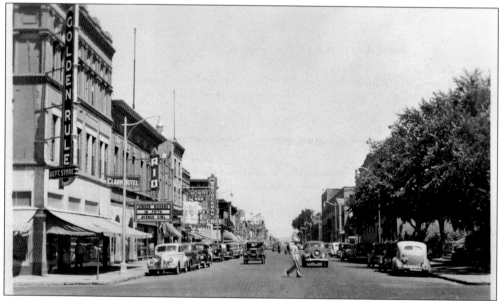

When this postcard picture was taken in the early 1940s, the Golden Rule was the main business in the Clark Hotel building. Ten years later, the Coast-to-Coast took over the site. The Rio Theatre was located in the Losekamp building, originally called the Liberty, in 1929. It showed all the latest movies for 15¢. The marquee reads, "Ginger Rogers in Fifth Avenue Girl." Note the large mature trees in front of the old Parmly Billings Memorial Library. (KFR.)

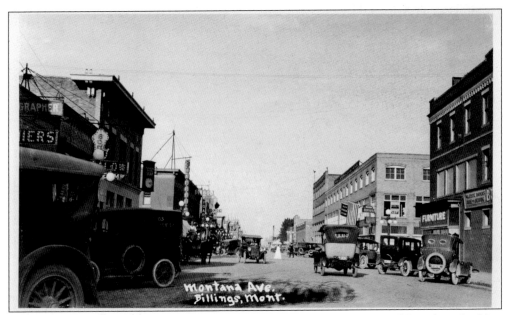

This early-1920s postcard shows a very busy day on Montana Avenue and Broadway looking east. The two-story building on the left is the Yellowstone National Bank (Midland), founded in 1891 at 2707 Montana Avenue. In 1909, W. A. Selvidge built the two-story Billings Hardware (far right). Across the street, to the east, was the 1916 Babcock-Selvidge Building, which housed Sears for many years. (CC.)

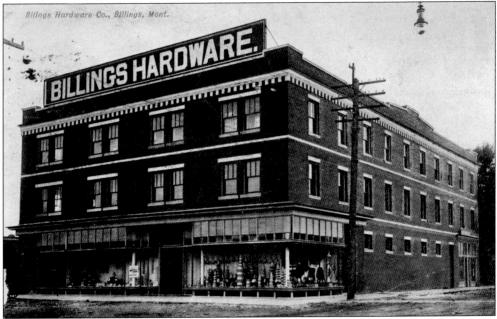

In 1903, W. A. Selvidge bought out the old Babcock Hardware. He renamed the business Billings Hardware. In 1909, Selvidge built a structure on the original site of the 1893 Northern Pacific depot. In 1955, the Billings Hardware moved to a new building located at 510 North Broadway, present site of the Parmly Billings Memorial Library. The old building became Colborn School Supply. (AHC.)

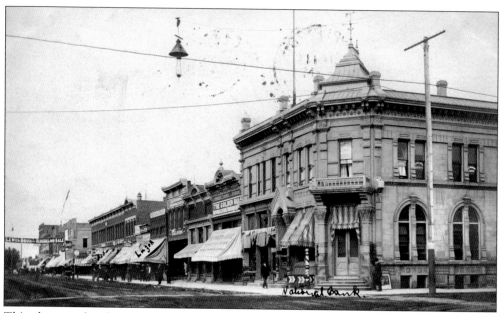

This photograph is looking west at the intersection of Montana Avenue and Twenty-seventh Street in 1907. All the buildings on this block were constructed in the mid-1880s. They were the most architecturally detailed in the city. The Luzon Café, the name written in pen in the center of the postcard, was Billings's oldest restaurant. It served great meals for over 70 years at the same location. Today nothing is left of this once stately block. The last three buildings, in the center of the block, were torn down in 2005 to make way for a parking lot. At the beginning of the block, 2701 Montana Avenue, was the 1886 First National Bank (Gazette) building.

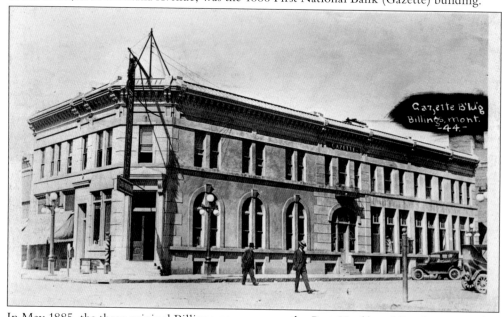

In May 1885, the three original Billings newspapers—the *Post*, *Herald*, and *Rustler*—merged to form the *Billings Gazette*. Over the years, the *Gazette* moved several times until the paper found a permanent home at 2701 Montana Avenue (shown above). The Gazette Building was torn down to make way for a new chamber of commerce structure.

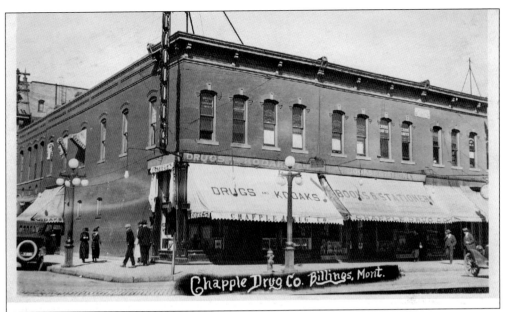

Chapple Drug was located at 2723 Montana Avenue. In 1893, three Chapple brothers—Henry, James, and Charles—opened the most well-known drugstore in town. The youngest brother, Charles, took over the managerial job in 1895 and was in charge until his death in 1945. The store's slogan was well known: "Get it at Chapples." In 1957, the Chapple Drug building and several others were torn down to make way for the three-story Northern Hotel parking garage. (CC.)

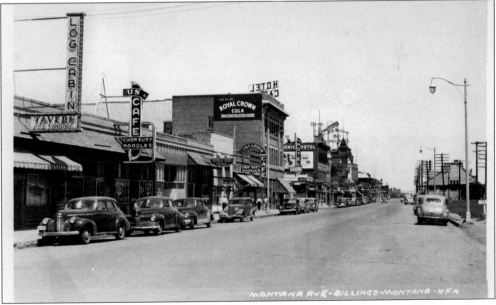

This rare mid-1940s view shows the 2600 block on Montana Avenue, one of the most intact historic blocks in Billings. The single-level structure was built in about 1906 with the 1913 Carlin Hotel at the end of the block. The US Café and St. Lewis Café both served chop suey noodles at the same locations for over 40 years. Most of the block received complete renovations in the late 1990s as part of a downtown revitalization project. (KFR.)

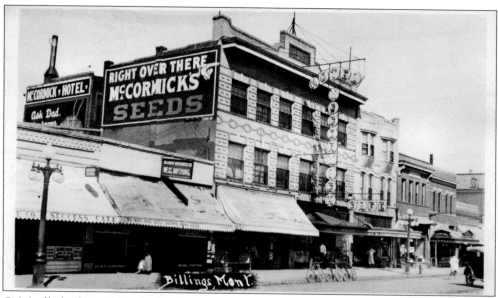

Originally built in 1905, the McCormick Hotel is located at 2417 Montana Avenue. William H. McCormick, a farmer, built the hotel and leased it to different parties over the years. On the left side of the hotel, McCormick advertised his hay and seed business, which can be seen today. It was located across the railroad tracks at 2500 Minnesota Avenue. The three-story Eagle Hotel, to the right of the McCormick Hotel, was built in 1909 by Matthias Thomas. Chief Plenty Coups stayed in the Eagle several times.

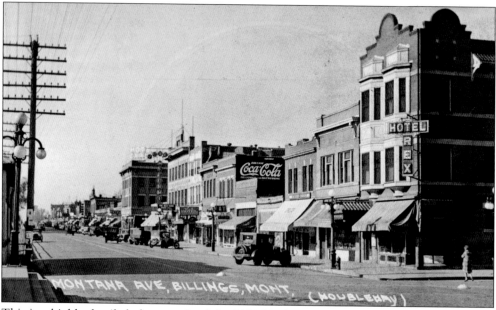

This is a highly detailed photograph of the 2400 block of Montana Avenue looking west. In the center of the block is the Oxford Hotel, flanked by the painted Coca-Cola sign and built in 1909. Today the hotel houses an antique store. Three buildings to the right of the Oxford Hotel was Deckers Curio Shop, which carried a wide selection of Native American artifacts and souvenirs. The 1910 Rex Hotel is on the far right. In the 1980s, it was renovated into the present Rex restaurant. (RD.)

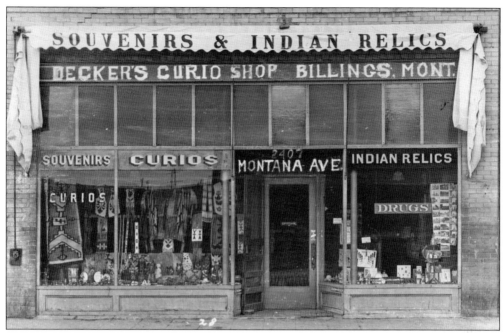

Jean P. Decker (1860–1920) left Iowa in 1877 for the Dakota Territory and upon arrival found odd jobs in the rough-and-tumble town of Deadwood. It was at this time Decker found his true calling as a newspaperman. Over the next 30 years, he had editor and reporter jobs all over the Pacific Northwest. In 1900, Decker took the editor job at the *Billings Gazette*. He remained at the job for seven years. In 1913, he bought a drug and curio store owned by Lee Warren at 2407 Montana Avenue. Decker died in 1920, and his wife, Josephine, ran the curio store until her death in 1941. The above postcard shows the exterior view of Decker's Curio Shop store with all its "souvenirs and Indian relics;" below is the interior view of the store.

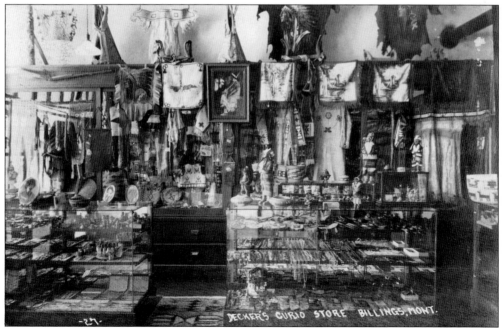

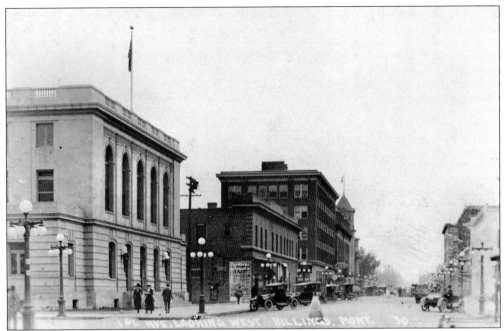

This late-1910s postcard is a view of downtown Billings looking west on First Avenue North and Twenty-sixth Street. On the left side of the card is the old post office built in 1913. Over the years, it was remodeled and enlarged several times. Next to the post office is the El Niblo (James) Hotel, built in 1907 by Peter Smith at a cost of $50,000.

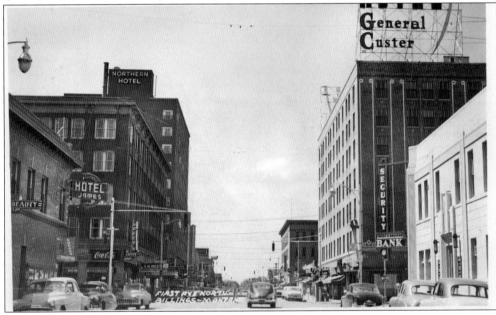

By the 1940s, Billings was on track to becoming the largest trade center in Montana. This card shows First Avenue North and Twenty-seventh Street looking west. On the right side of the card are the Hotel General Custer and the Security Trust and Savings Bank across the street. The building on the left side of the postcard is the James Hotel, present site of the Crowne Plaza, followed by the Securities Building and the 10-story Northern Hotel. (KPR.)

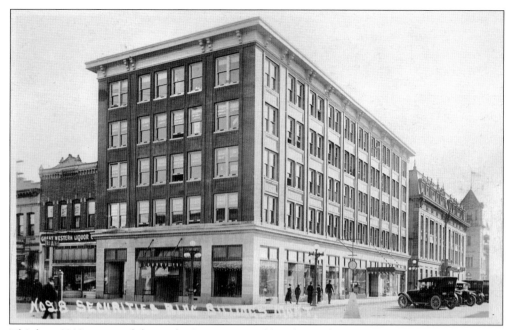

This late–1910s postcard shows the Securities Building located at 2708 First Avenue North. The lower floor housed a variety of businesses over the years, with the upper four floors reserved for office space. The original Yellowstone County Courthouse occupied this site from the 1890s until it was torn down in 1905. In early 2003, the Securities Building was completely remodeled to its former glory.

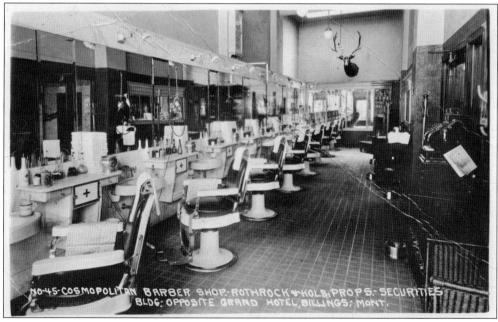

The Rothrock and Kolb barbershop's first location was in the basement of the Mowres Cigar Store on Montana Avenue in about 1910. A few years later, it moved to 103 North Broadway. In about 1918, Rothrock and Kolb moved into the Securities Building and was the largest of 18 barbershops in Billings. (WAI.)

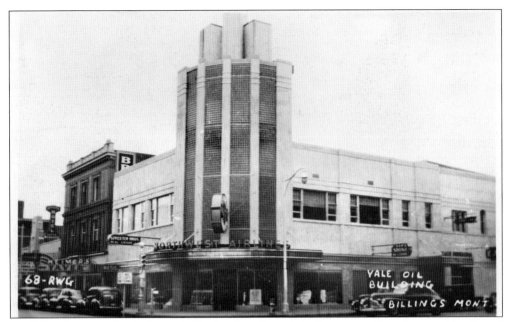

In 1940, the new city hall was built, leaving the original one, on First Avenue North and Broadway, empty and its future uncertain. The Yale Oil Company, which opened a refinery in Billings in 1929, bought the building and started extensive remodeling. One of the main tenants was Northern Airlines' district office, located in the lower front corner of the building. Northwest had three round-trips daily between Chicago and Seattle in 1944. (RWG.)

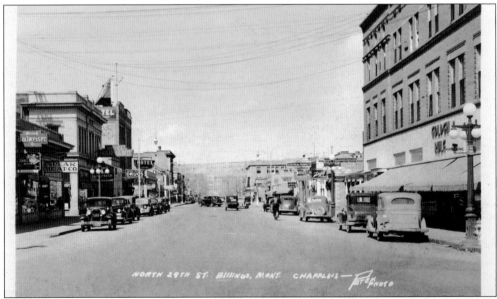

This is just an interesting view of North Twenty-ninth Street and Montana Avenue looking north. Under magnification, McMullen Hall, on the Montana State University Billings campus, can be seen at the base of the Rims. The Harvard Hotel, second building on the left, housed the Sturm and Drake's groceries, hay, and grain store. Note the large painted advertising sign for Sturm and Drake can still be seen in the alley. I. G. Petek took this photograph. His studio was located at 2704 First Avenue North. (JJP.)

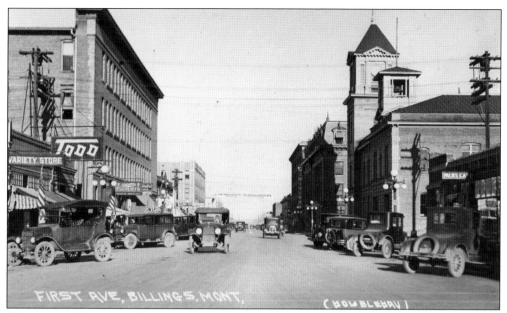

This early-1920s postcard is a view of First Avenue North and Twenty-ninth Street looking east. The Todd shoe sign can be seen next to the Stapleton Building. Lester Todd opened his shoe store in about 1906 and was in the same location for over 60 years. The old city hall with the Billings Fire Department in the rear can be seen on the right. The original Maverick Hose Company bell, seen in the bell tower, can still be viewed on the Montana State University Billings campus. (RD.)

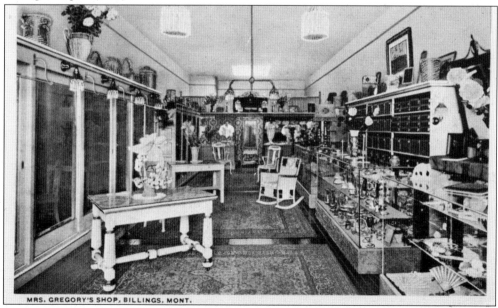

Helen Gregory opened her ladies' apparel store in 1906 at 2819 First Avenue North. In 1922, she moved to a new store at 216 North Broadway, just behind Hart and Albin's. Gregory was a symbol of fashion, and no one dared challenge her eye for it. If a customer seemed hesitant about a recommended dress, she would say, "Wear it or else." Gregory's shop was in business for over 55 years.

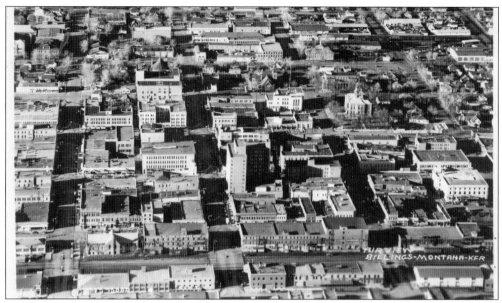

This card shows an aerial view of Billings's downtown business district looking north. By the 1930s, Billings was the main trade center for the Midland Empire, consisting of eastern Montana and northern Wyoming. The Northern Hotel (center) was the tallest building in Montana in the 1940s. The old Yellowstone County Courthouse, built in 1903, can be seen in the upper right side of the card. Toward the bottom of the card from left to right are the Northern Pacific Railroad tracks. (KFR.)

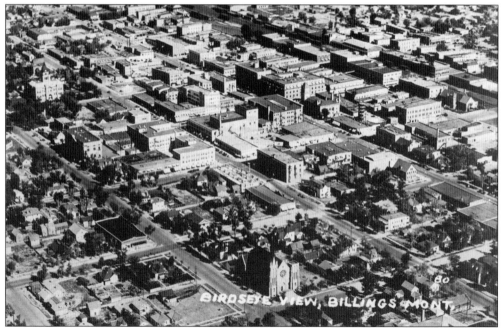

Postmarked 1936, this aerial view shows Billings's downtown district looking southeast. St. Patrick's Co-Cathedral can be seen in the lower center of the card. Even by the mid-1930s, residential houses were still commonplace where business buildings now stand. In the upper left is the old Yellowstone County Courthouse. (RTC.)

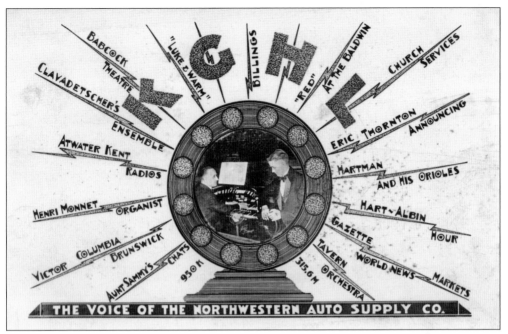

In the late 1920s, Charles Campbell, manager of the Northwest Auto Supply, was convinced that building a radio station was a way to push radio receivers. The KGHL radio station started broadcasting on June 8, 1928, throughout the Billings area. The large variety of programs broadcasted on KGHL can be seen on this 1930 postcard sent from Billings. In 1932, KGHL became affiliated with the National Broadcasting Company (NBC), which brought in programming from across the nation. The bottom postcard shows the KGHL radio station in the late 1930s. It was located 6 miles west on the old Laurel Highway near the Shiloh exit. In 1935, the radio station announced that it had the nation's highest aerial, measuring 558 feet high and costing $18,000. (Below, RGW.)

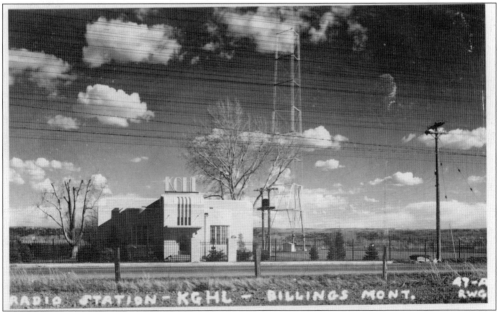

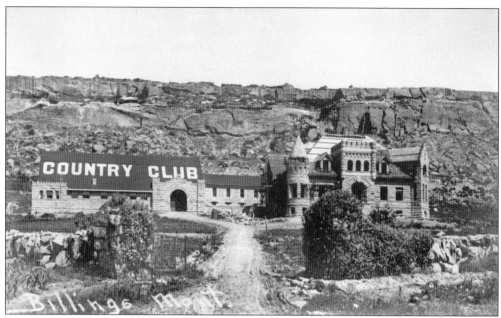

In 1892, the State of Montana appropriated $65,000 for a prison to be built in Billings. The building stood at the head of Eighteenth Street under the shadow of the Rims, but the Billings Penitentiary was never finished. In 1904, Austin North, real estate man, bought the unfinished prison in the hopes of turning it into a country club. Austin North and his family lived in a small house behind the sandstone structure while it was being renovated. He worked on the project as money allowed but was unable to finish the country club. In the early 1930s, the government wanted to buy the old country club in the hopes of turning it back into a prison. In March 1933, the country club was destroyed by fire. The large sandstone blocks were hauled away and used for other buildings. The above postcard shows a front view of the country club about 1910. In the card below is a rare view looking northwest.

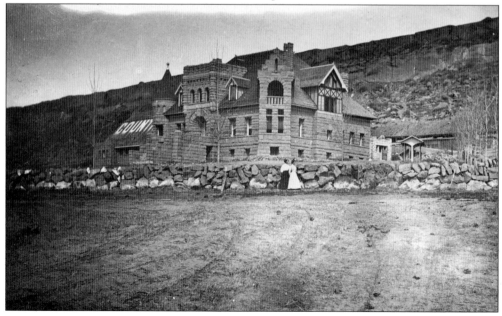

Two

THEATERS, BANKS

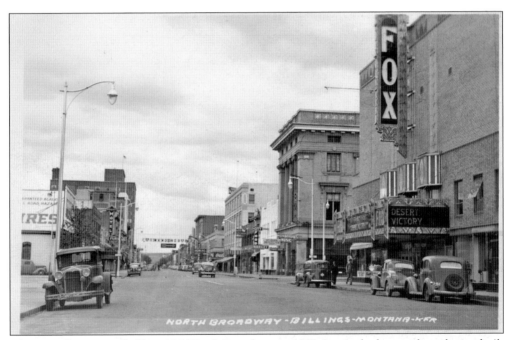

The Fox Theatre was built at 302 North Broadway in 1931. It was the last art deco theater built in the United States. The Fox had a seating capacity of 1,500 people with an upper and lower balcony. The outside ticket office was an outward thrust covered in beautiful marble. The lobby of the theater reflected the influence of the art deco movement, and patrons were seated by well-dressed young ushers. The Fox carried a variety of new films along with community concerts. In 1987, the Fox was remodeled extensively and renamed in honor of philanthropist Alberta Bair. (KFR.)

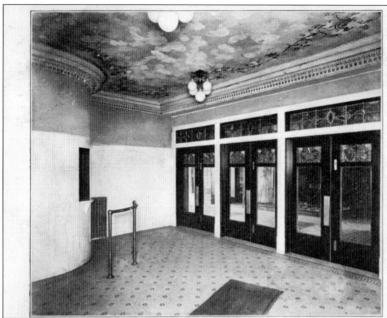

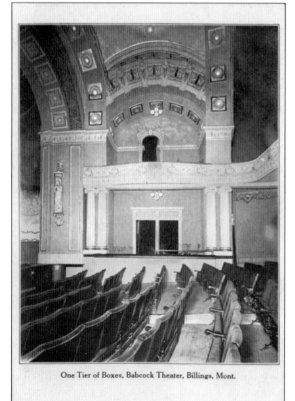

One Tier of Boxes, Babcock Theater, Billings, Mont.

In December 1907, A. L. Babcock opened the $150,000 Babcock Theatre with a play, *Blue Moon*. Paul Enevoldeen conducted a six-piece orchestra, which accompanied vaudeville and road shows. A $20,000 Wurlitzer organ was installed to serve as the centerpiece of the theater. This 1908 interior view above shows the ticket part of the lobby. The room had a beautifully painted ceiling and large stained-glass doors with a tiled floor. The postcard at left shows the side tier of boxes along ornate arches and hardwood seats. In 1935, the Babcock was completely gutted by fire. The Babcock was refurbished and reopened, but it had lost most of its original beauty. Movies ran in the theater until the late 1980s. (Both, MPC.)

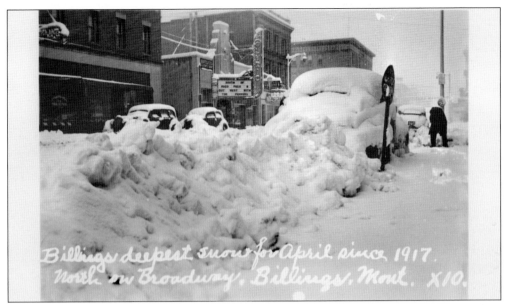

This view shows the April 17, 1941, snowfall, the deepest since 1917. Billings had a howling blizzard that shut down the entire city for several days. Roofs of several businesses collapsed under the weight of 30 inches of wet heavy snow. The building in the center background is the Lyric Theatre at 14 North Broadway. It was started in 1916 and was known by many names over the years, such as Majestic, Strand, Myrick, and in 1927 the Lyric. The movies showing on the marquee are *South of Pago Pago* and *Out West with the Peppers*.

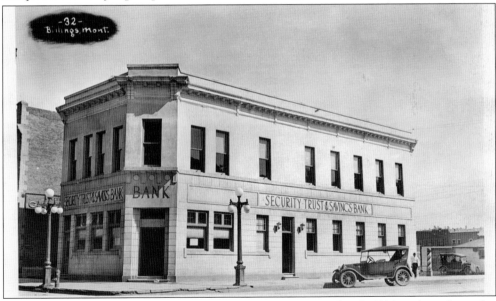

The Security Trust and Savings Bank opened its doors on October 9, 1916, and was located at 2701 Montana Avenue. It soon moved to larger quarters at the corner of First Avenue North and Twenty-seventh Street and was at that location for over 35 years. In 1955, the bank moved to its final location on Third Avenue North and Twenty-ninth Street and became Montana's largest bank. The postcard shows the Security Trust at its second location after it had been remodeled for the first time.

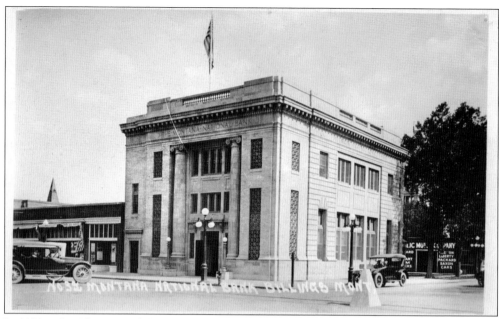

In 1912, John Clay opened the Bank of Billings at 2701 Montana Avenue and a year later moved to the corner of Broadway and First Avenue North. By 1917, the bank had reached sufficient size to build a more permanent structure at 203 North Broadway. In that same year, the bank took on a national charter under the name Montana National Bank with $100,000 in capital. In the late 1990s, the bank closed, and the building now houses law offices.

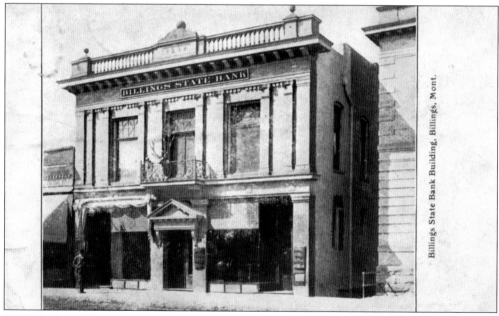

In 1901, the Billings State Bank was opened by Paul McCormick. He was president of the Custer Cattle Company and a longtime businessman in Billings. He constructed this two-story bank building at 20 North Broadway. Note the large Elk head mounted over the bank entrance. In 1908, Lee Mains took over the bank as president, and it was renamed the American Bank and Trust company with a capital of $150,000. (MPC.)

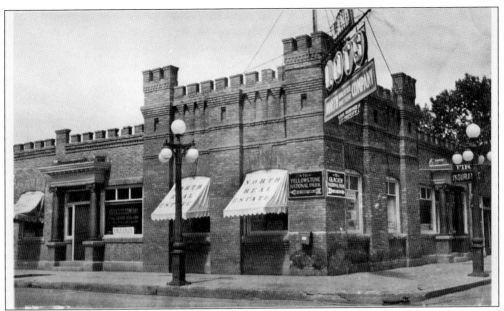

Austin North (1869–1928) moved to Billings in 1889. He was a tireless promoter of Billings and the Midland Empire. North organized the Austin North Company in 1892 to deal in real estate, mortgage loans, and insurance. His office was located in the First National Bank building on Montana Avenue. In 1902, he relocated his office to a new building at the corner of Twenty-seventh Street and Second Avenue North. The Austin North Bank was opened in 1905 but only lasted a few short years. After North moved to San Antonio, Texas, in 1922, his two brothers, Jo and Oto, took over most of the real estate business. The card shows the exterior view of the North Real Estate Investment Company at 202 North Twenty-seventh Street. The card below shows the interior view of the highly detailed Austin North Bank. (Below, BBP.)

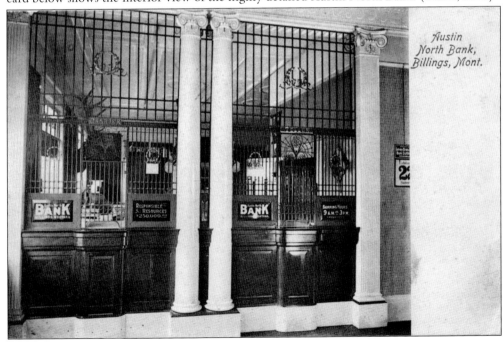

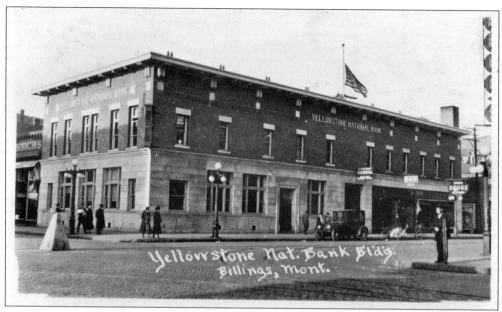

Yellowstone Nat. Bank Bldg.
Billings, Mont.

The banking house of E. G. Baily and Parmly Billings, son of Frederick Billings, was opened in 1886. After Parmly's death in 1889, Baily started selling his interest in the bank to Albert Babcock. In 1891, the Yellowstone National Bank was formed by A. L. Babcock and David Fratt. The new bank was located at 2707 Montana Avenue with a capital of $150,000. The postcard shows the bank at its second location at 2801 Montana Avenue in about 1920. (CC.)

In 1923, the Yellowstone National Bank and Merchants National Bank merged to become Midland National Bank at 4 North Broadway. In 1955, Midland National Bank moved to its new eight-story building at Broadway and Third Avenue North. The bank name was changed to First Bank in the 1970s and finally to U.S. Bank. In the early 1990s, the bank's exterior was covered with dark glass. (EPC.)

Three

HOTELS, HOSPITALS

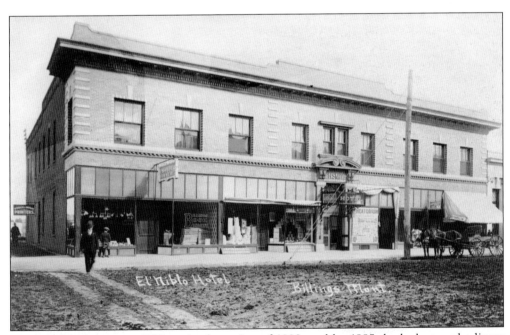

Peter H. Smith came to Billings in the spring of 1882, and by 1885, he had opened a livery business on Twenty-seventh Street. In 1907, on the same site of the old livery stables, he built the Smith Block at a cost of over $50,000. The upper floor was occupied by the El Niblo Hotel, later renamed the James. In 1978, the building was torn down to make way for the Sheraton Hotel (Crowne Plaza).

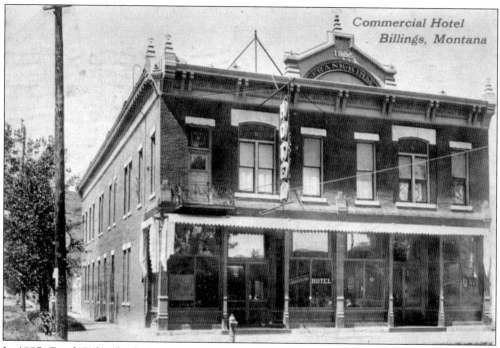

In 1885, Frank Kihm built the Driscol Hotel at 2523 Montana Avenue. Shortly after 1900, the hotel was renamed the Commercial. Teddy Roosevelt gave a speech to a crowd of 8,000 in 1911 from a small second-story wrought-iron balcony on the left side of the hotel. The building was razed in 1967 to make way for a parking lot. (AJH.)

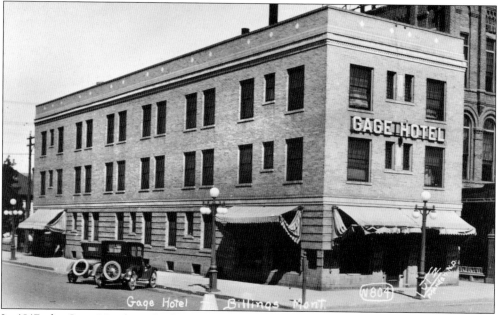

In 1917, the Gage Hotel was built on the corner of Twenty-fourth Street next to the Billings Brewery plant. Phil Grein, retired president of the brewery, was the manager of the Gage. The hotel was designed next to the brewery using steam heat from the kettles to warm the rooms. In the early 1970s, the Gage was razed and turned into a parking lot. (Lutz.)

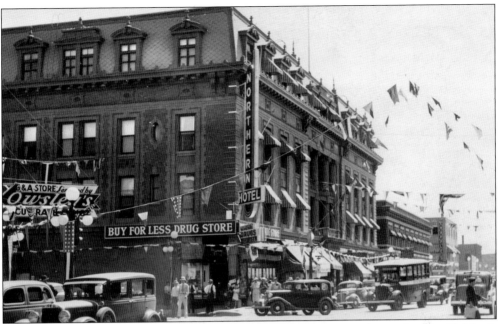

In 1902, P. B. Moss and H. W. Rowley started building the Northern Hotel at 19 North Broadway. When the $60,000 hotel was finished, it had 69 rooms. In 1916, a fourth floor with dormer windows was added, which mostly consisted of larger apartments. Salesmen of the Midland Empire paid $1 a night to stay at the Northern. Larry Bennett owned the Buy for Less Drug Store, opened in 1938 and located in the front corner of the Northern.

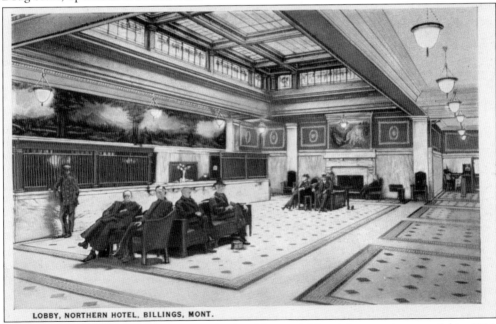

LOBBY, NORTHERN HOTEL, BILLINGS, MONT.

The original 1903 Northern Hotel was built without a lobby. After a major remodel in 1914, the Northern had one of the most beautiful lobbies in Montana. The hotel desk and walls were covered with marble, and there were finely polished tiled floors. The ceiling had a large stained-glass skylight trimmed in heavy mahogany. (BBP.)

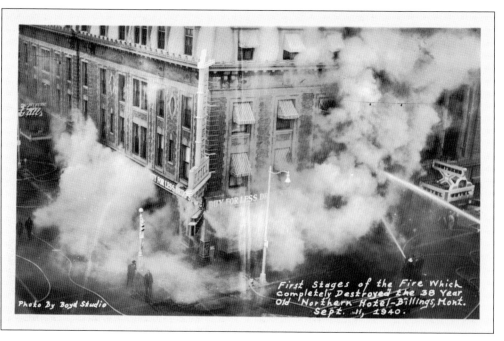

On the afternoon of September 11, 1940, fire broke out in the 35-year-old Northern Hotel. At the time of the fire, the hotel had 200 rooms. The fire burned all night. The Billings Fire Department was unable to get water deep inside the mostly wooden interior. By the next morning, the hotel was completely gutted, leaving only a few exterior walls standing. The loss was estimated at over $600,000. The above postcard shows the early stages of the fire with the Billings Fire Department on the scene. The postcard below shows the Northern totally in flames during the night. (Both, BS.)

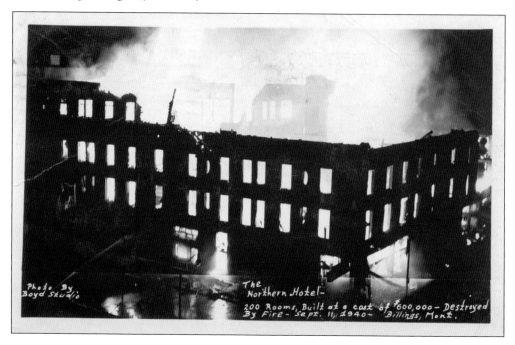

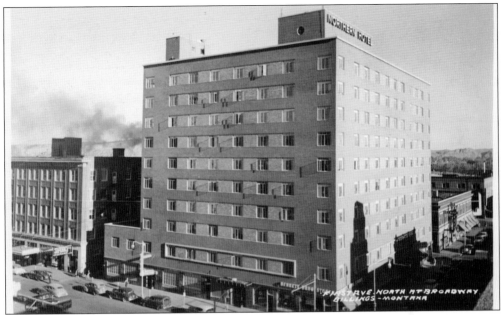

Almost as soon as the last embers were put out in the Northern Hotel fire, P. B. Moss and the estate of H. W. Rowley started plans to rebuild the Northern. Rebuilding the Northern was slowed because of the material shortage during World War II. The present 10-story structure was opened on July 7, 1942, at a cost of $1 million. In 2006, the Northern was closed with the hopes of reopening sometime in the future. (KFR.)

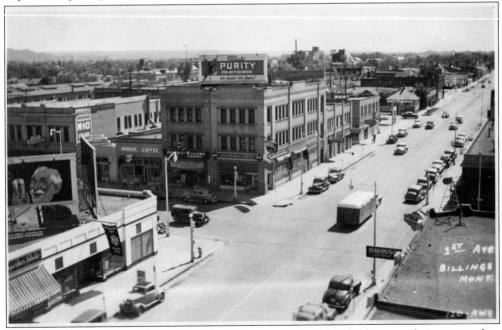

This aerial view of First Avenue North and Twenty-ninth Street, looking southwest, was taken from on top of the Stapleton Building. In the center of the postcard is the Olive Hotel with a large advertising sign selling Purity bread. The two large signs (far left) are advertising Old Fashion Beer for the Billings Brewery. (RWG.)

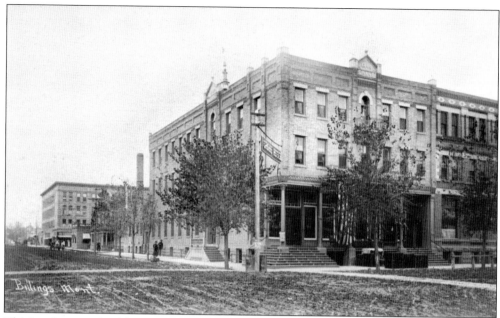

This is a photograph of the Grand Hotel, taken about 1908, located at 102 North Twenty-seventh Street. The original Grand Hotel was built in 1886 by John J. Walk and O. M. Nickey. In 1896, George Benninghoff and sister Julia bought the brick hotel for $12,000. The Benninghoffs built a three-story addition to the north in 1898. The Grand provided the city's first private room bathtub.

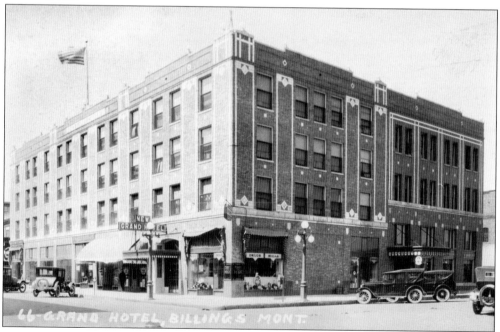

In 1921, just one year before retiring from active hotel ownership, the Benninghoffs razed the original three-story Grand Hotel. A new four-story hotel was built and renamed the New Grand. The new hotel was leased by Carrie Cruse until 1938. Les W. Carter took over the management until the hotel was sold in 1945.

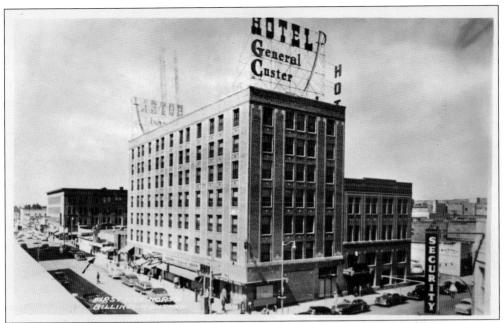

In 1945, the Benninghoff family sold the Grand to J. C. Boespflug and Thomas Thain. Under the new ownership, the Grand was expanded to a total of 175 rooms by the addition of three stories to the hotel. In 1951, the Grand Hotel was renamed Hotel General Custer. By the early 1970s, the hotel closed and the rooms converted into office space. (KFR.)

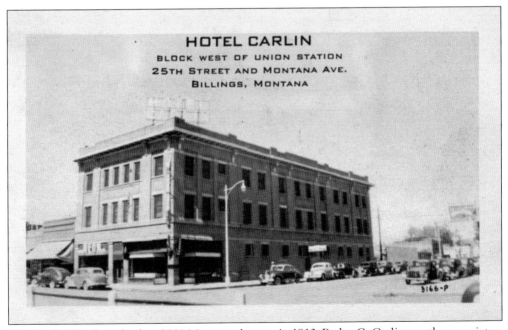

The Carlin Hotel was built at 2501 Montana Avenue in 1913. Parlee G. Carlin was the proprietor. The hotel served as a canteen during World War I as troops came by train through Billings. As of 2008, the Carlin is an extended-stay hotel with a lively bar on the street level. (NP.)

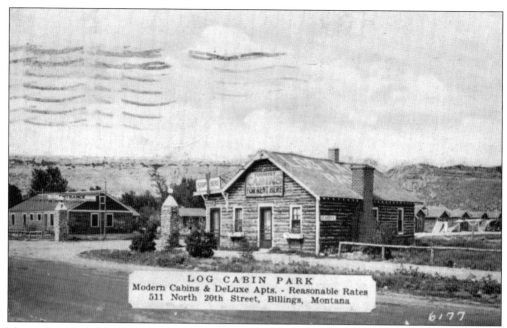

LOG CABIN PARK
Modern Cabins & DeLuxe Apts. - Reasonable Rates
511 North 20th Street, Billings, Montana

Shown in this 1938 postcard, the Log Cabin Tourist Park was located at 511 North Twentieth Street. It was built by H. J. Nibbe in 1932, who ran the park for many years. In 2008, the two main buildings, pictured above, were razed to make way for a multistory bank building. (KBI.)

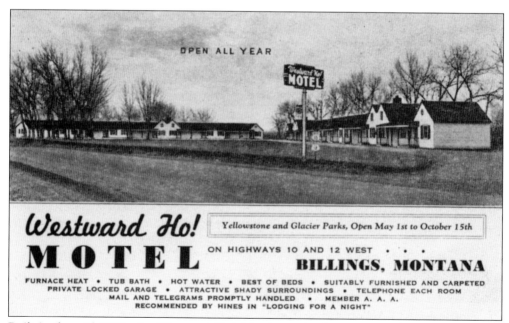

Westward Ho!
MOTEL

OPEN ALL YEAR

Yellowstone and Glacier Parks, Open May 1st to October 15th

ON HIGHWAYS 10 AND 12 WEST · · ·
BILLINGS, MONTANA

FURNACE HEAT · TUB BATH · HOT WATER · BEST OF BEDS · SUITABLY FURNISHED AND CARPETED
PRIVATE LOCKED GARAGE · ATTRACTIVE SHADY SURROUNDINGS · TELEPHONE EACH ROOM
MAIL AND TELEGRAMS PROMPTLY HANDLED · MEMBER A. A. A.
RECOMMENDED BY HINES IN "LODGING FOR A NIGHT"

Built in the mid-1940s, the Westward Ho! Motel was the first true motel in Billings. It was located at the beginning of Central Avenue. The Westward Ho! had all the modern conveniences a traveler could want: a bathtub, hot water, garage, and a telephone in each room. It was later renamed Overpass Motel and razed in 2009.

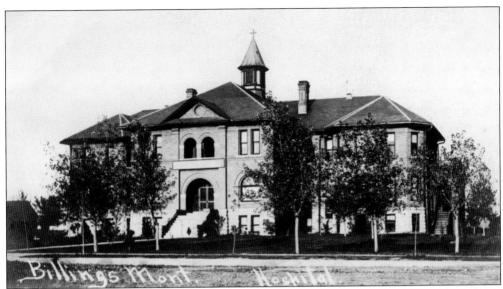

Until the first St. Vincent Hospital was built in 1899, citizens of Billings would travel to Chapple Drug at 2723 Montana Avenue. Dr. James Chapple (1870–1932) would treat the sick in his office above the drugstore. With the help of Dr. Henry Chapple (1861–1900), brother of James, Fr. Francis Van Clarenbeck and the Sisters of Charity of Leavenworth, Kansas, opened the new $40,000 St. Vincent Hospital. The hospital was located on Division Street between Broadway and Wyoming Avenue. After 1923, the hospital was used for handicapped children. In 1947, it was torn down to make way for the present Central Catholic High School.

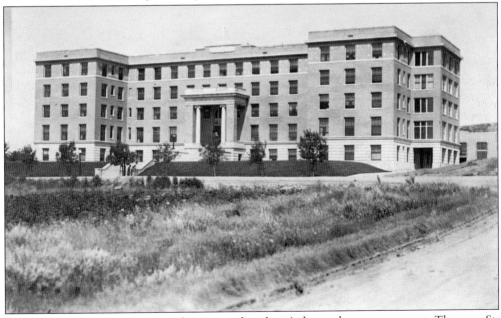

By 1917, the need for a larger and more modern hospital soon became apparent. The new St. Vincent opened its doors in 1923 at North Thirtieth Street and Twelfth Avenue North at a cost of $250,000. At the time of the building, citizens of Billings thought the location was crazy because it was so far out of town. In 1947, Merillac Hall was added to the north of the main building.

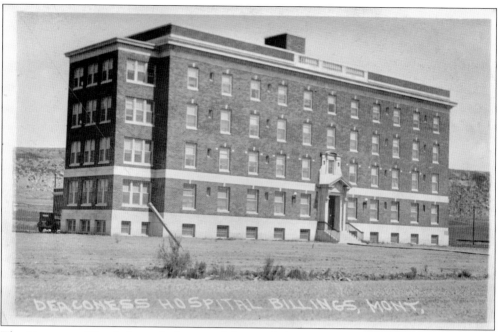

The Deaconess Hospital was built out of the need for a second hospital. Billings residents thought St. Vincent was too overcrowded, and people wanted a nonsectarian hospital. In 1917, a fund drive was begun to collect $100,000 to begin ground-breaking at 2815 Ninth Avenue North. Due to World War I, only a fourth of the new hospital was built. It was not until 1927 that the Deaconess opened with a staff of 12 doctors and 16 nurses.

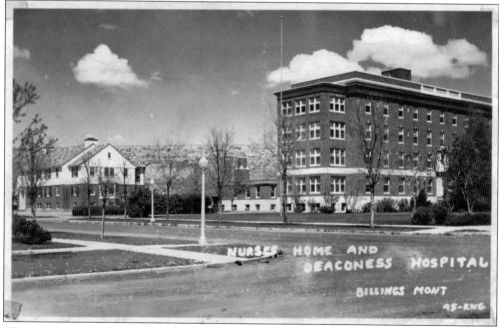

This is a view of the Deaconess Hospital and nurses' dormitory looking northeast from Twenty-ninth Street. The hospital opened a trade school for nurses in 1927. The program was taken over by Montana State College of Nursing at Bozeman in 1945.

Four

BREWERIES, BARS, RESTAURANTS

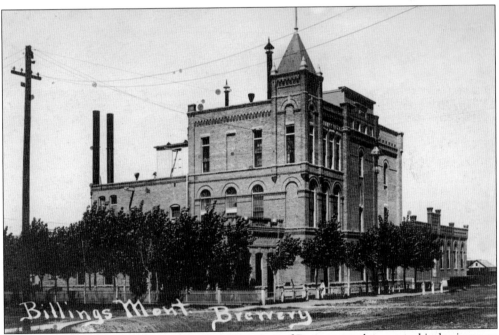

In the late 1890s, the Centennial Brewing Company of Butte wanted to expand its business, so it looked to Billings to start a new brewery. Phil Grein, manager of the new brewery, started at once to build the three-story steel and brick structure costing an estimated $100,000. The brewery was capable of producing 200,000 barrels each year. In the spring of 1900, the first gallons of Old Fashion Beer were produced in the brewery located on the 2300 block of Montana Avenue. After Prohibition ended in 1933, the brewery reopened with much fanfare. Brewery producers stated many problems along with the competition from large Midwest breweries caused the demise of the Billings brewery in 1952. The building was torn down in 1959.

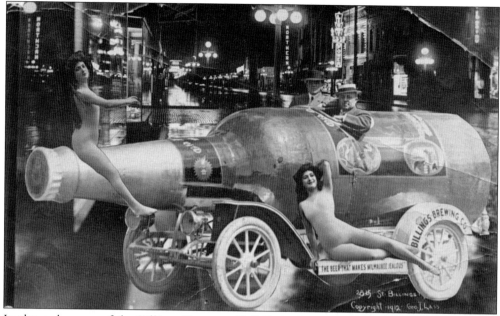

In the early years of the Billings Brewery, Phil Grein (president) and Ray Wise (secretary-treasurer) understood the need to advertise the Old Fashion Beer brand. In about 1910, they built a large beer bottle car that promoted Old Fashion Beer, "the beer that made Milwaukee jealous." George Lass used a three-layer process to create this rare bottle car postcard. After many years of parades and special events, the brewery bottle car was scrapped for metal. (GJL.)

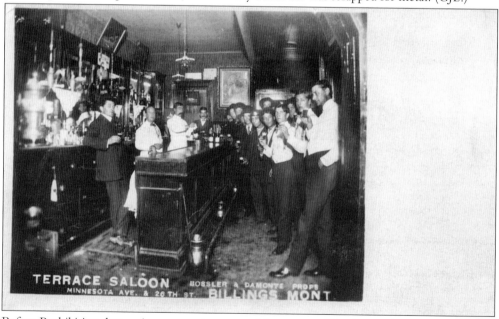

Before Prohibition, breweries were not prevented from controlling bars. The Billings Brewery leased several lots to those who promised to opened saloons. In a short time, the bars, controlled by the Billings Brewery, sold Old Fashion on tap. This rare interior view shows a large group of men having a short Old Fashion beer on tap. When this 1907 postcard was taken, there were 42 saloons in Billings, which had a population of about 8,000.

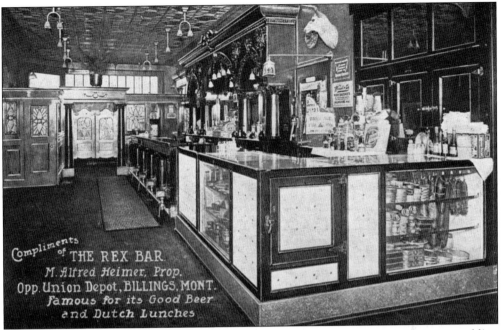

In 1910, William F. ("Buffalo Bill") Cody gave his financial support to Alfred Heimer, enabling him to open the Rex Hotel and Bar at 2401 Montana Avenue. Heimer was Cody's personal chef while on the Wild West Show tours. The interior view shows the Rex bar with its beautiful bar back and display case showing a variety of cold meats.

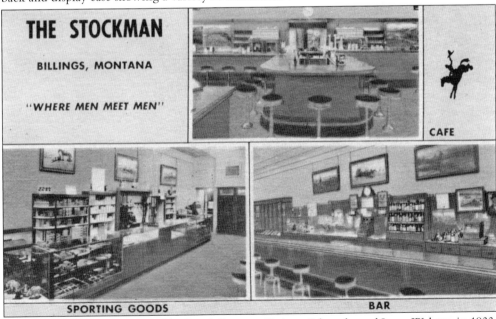

The Stockman Bar was opened by Frank Rogers, Quincy Edwards, and Jason Webster in 1933. It was located at 2805–2809 Montana Avenue and consisted of a bar, a line of sporting goods, a lunch counter, and a barbershop. The Stockman advertised itself as a place "where men meet men," which would not lend itself to today's society. Will James, writer and illustrator, was known to "tie one on" at the Stockman. It finally closed in 1965. (MWM.)

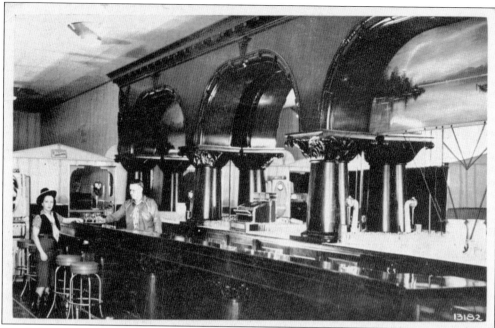

The Sylvan Lounge and Club opened in the early 1940s at 20 North Twenty-seventh Street. It lasted for less than 10 years. Collett Casey bought the beautiful mahogany bar back and had it moved to Casey's Golden Pheasant bar, located at 2622 Minnesota Avenue. Today the 1905 bar back can be seen at the last location of Casey's, 222 North Broadway. (DP.)

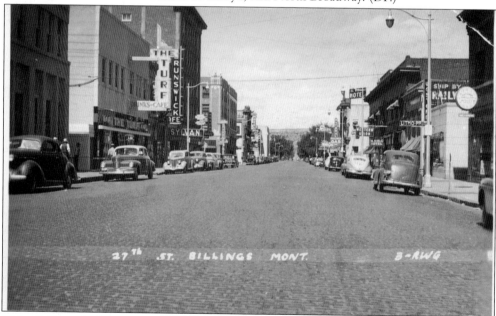

This 1940s real-photo postcard is looking up North Twenty-seventh Street at the Turf, Brunswick, and Sylvan Cocktail Lounge. The three bars were located next to each other and were dear in the memories of many old-timers. Note the beautiful red paved brick, which was covered over with asphalt. In the late 1930s, the city took down the five-globe streetlights and replaced them with a taller single streetlight. (RWG.)

The Skyline Club was located 1 mile west of the airport. Charles Myers built the nightclub as his private home in about 1917. When the family moved on in 1944, the home was turned into a nightclub. In 1956, Mike Basile ran the club for nine years as the Bella Vista. In 1969, the new owners changed the name to the Skyline Club. A fire destroyed the club on July 4, 1971. (WASC.)

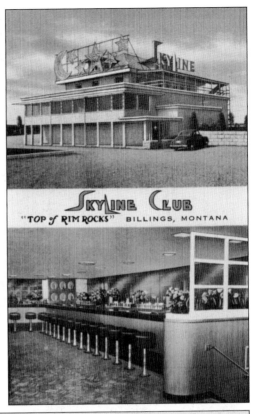

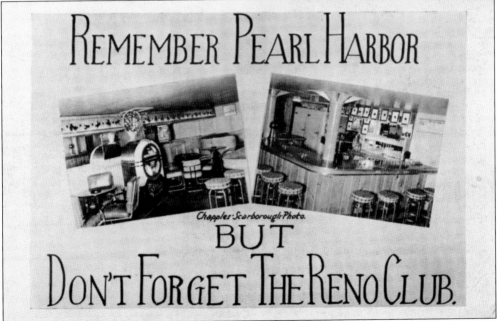

The Reno Club was opened by Vern Daniels at 20 North Broadway in the late 1930s. The club was advertised as Montana's first cocktail lounge. Today the club is located at 150 Calhoun Lane and is still run by the family. (CC.)

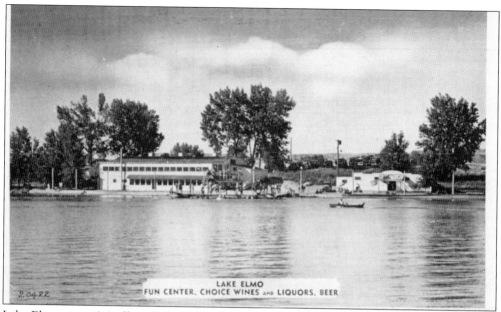

LAKE ELMO
FUN CENTER, CHOICE WINES AND LIQUORS, BEER

Lake Elmo was originally called Holling Lake and was used as a reservoir for irrigation water. The lake was renamed for Elmo McCracken, who owned land along the shore. In 1929, he started to develop his property along the shore into the Elmo Club. He built a 140-by-75-foot structure that housed the dining room and dance floor. In 1945, Bob Porter bought the club and conducted extensive renovations. On the night of December 29, 1946, the Elmo Club burned to the ground with over $100,000 in damage. The Billings Fire Department could not respond because the nightclub was out of the city limits. After the fire, Bob Porter rebuilt the Elmo Club across town on the old Laurel Highway near the present-day Muzzle Loader Café. The above postcard shows the Elmo Club from across the lake. The photograph below is the rebuilt Elmo Club on the old Laurel Highway. (Above, CWW.)

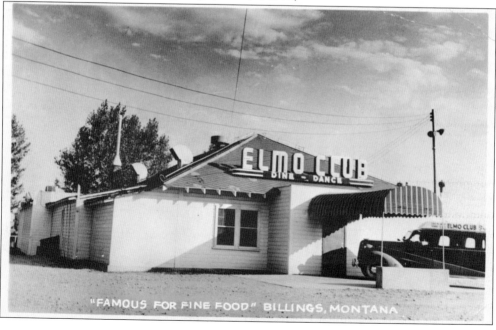

"FAMOUS FOR FINE FOOD" BILLINGS, MONTANA

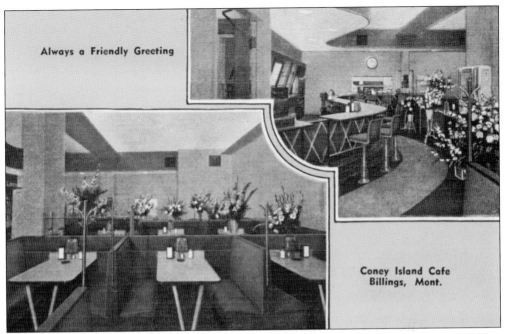

Always a Friendly Greeting

Coney Island Cafe
Billings, Mont.

T. G. Chakosand and Thomas Kalaris owned the Coney Island Café, located at 2717 First Avenue North, for over 30 years. They served merchants lunch for 25¢ and had evening steak dinners for 50¢ in 1940. Many young Billings couples went to the Coney Island for dinner before going to the Fox for a movie. (ECKC.)

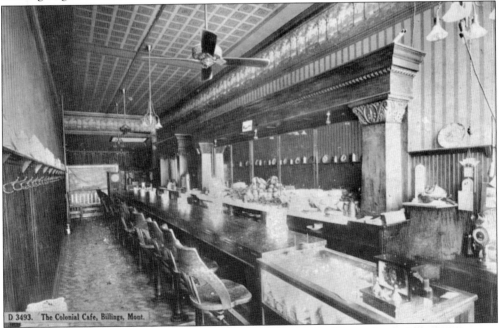

D 3493. The Colonial Cafe, Billings, Mont.

Robert E. Schendel opened the Colonial Café in about 1907, and it was located at 2815 Montana Avenue. It was well known throughout Billings for serving a great merchants lunch but could only feed 12 customers at a time. The café closed after 25 years of business. The site originally housed the 1886 Baily and Billings (Parmly) Bank. (TCC.)

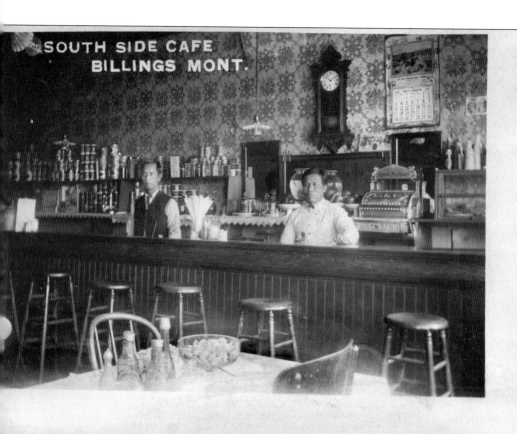

Thomas Hees's South Side Café, located at 2604 Minnesota Avenue, was one of four Chinese restaurants in Billings. In 1907, the menu carried a variety of Chinese and American dishes. During the 1920s and 1930s, the China Alley was located behind the South Side Café. In the dark dens beneath the alley, dreams were sold in the form of opium, cocaine, morphine, and heroin. Over the years, the police would raid the opium dens and arrest dealers only to have them reopen after the police left.

Five

PARKS, PARADES, FAIRS

From 1877 to 1882, Boot Hill Cemetery was the last burying ground for Coulson, Montana. Coulson was a small Yellowstone River town about 2 miles southeast of Billings. Hardly a night went by without a gunfight. The losers ended up dying with their boots on. The cemetery is located near the base of Black Otter Trail on the Rims. The first 21 people died violently along with two women and 10 children. By 1899, hardly any of the wooden markers were left to identify the dead's final resting place. In 1921, I. D. O'Donnell helped rededicate the cemetery and built the river rock obelisk at the north end of the cemetery. James D. Russell, the first person murdered in Billings on November 1882, is also buried at Boot Hill.

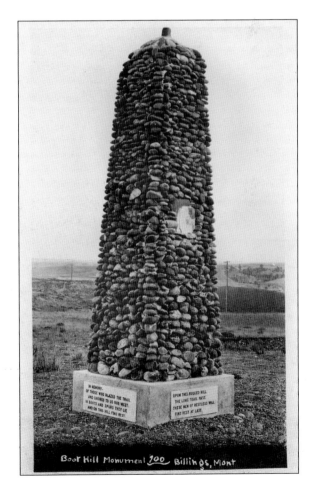

Boot Hill Monument 100 Billings, Mont

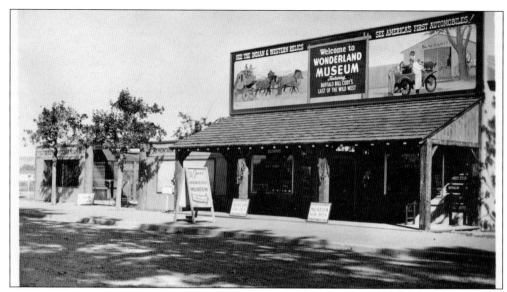

The Wonderland amusement park was located one block west of the Muzzle Loader Café on the old Laurel Highway. It was started by Don C. Foote, local businessman and hobbyist. One of his hobbies was collecting antique automobiles and restoring them to new condition. When Don ran out of room, he toyed with the idea of opening a museum. Don's father, John W. Foote, was an old-time Missouri carnival man who owned a traveling show consisting of an old steam merry-go-round and a medicine show. The father-and-son team felt that Billings was big enough to support a combination museum and amusement park. They bought a piece of land on the Laurel Highway and started to make plans for the park. Don then started to search out local interest attractions. The above postcard shows the main attraction, the Wonderland museum featuring Buffalo Bill Cody, with a gift shop located in the front of the building. The postcard below shows the interior view of the museum. It had over 1,000 Native American relics, stagecoaches, antique cart, and Western and historical items. Don even had on display Calamity Jane's personal diary. (Both, KFR.)

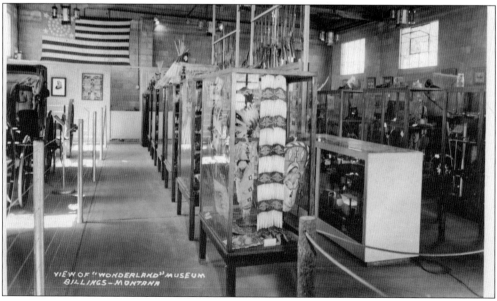

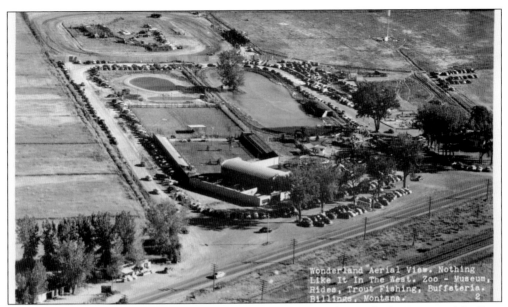

Don Foote drew up the plans, and within 90 days, the park was built. It opened in June 1950 with much community excitement. The park had many individual concessions. The Red Lodge Zoo was run by Les Lyons. Jake Groscop put in all the thrill rides, and Martin Knudson set up a Western Trails gift shop. Other concessions included a drive-in café, called the Oasis; pony ride; trout pond; radio station; and speedway for stock car racing. Wonderland had several fun rides, such as a 40-foot merry-go-round and a miniature Northern Pacific train that ran around a lake and through a tunnel. Lastly, a 45-foot Ferris wheel was erected near the center of the rides. In the end, the park only lasted about 12 years because of lack of attendance and a short season. The above postcard shows an aerial view of Wonderland with all its attractions. The racetrack can be seen in the far background. The view below is of the museum to the left followed by the merry-go-round, Ferris wheel, and the Oasis café to the right. Today only the museum building is left. (Both, KFR.)

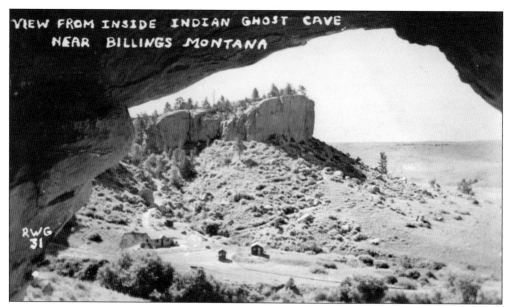

The pictograph caves were first excavated in 1937 by Prof. H. Melville, archaeologist from the School of Mines in Butte, Montana. The archaeologist found many pictographs and artifacts dating from recently to over 10,000 years ago. More than 30,000 artifacts were dug from Ghost Cave. An attempt was made to make the three-cave system into a tourist destination. The monument is located about 7 miles southeast of Billings off I-90 at the Lockwood exit. (RWG.)

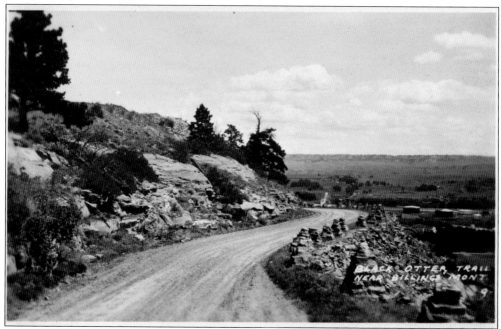

The building of a scenic road overlooking Billings was started in March 1936. Black Otter Trail was named after a Native American chief. The road building project was funded by the WPA and put 150 men to work at a cost of $20,000. The oil and gravel road project was to be finished within two months. (KFR.)

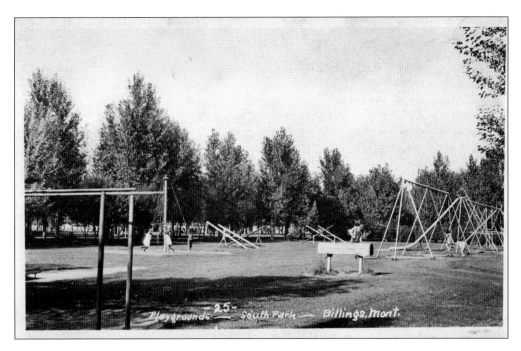

South Park was dedicated during a Memorial Day celebration in 1913. Dr. Frank Bell flew his Curtiss biplane over the park as part of the day's celebration. South Park is the first park in Billings consisting of 17½ acres and is still one of the most popular parks in the city. The 1914 swimming pool is the main feature of the park, but there are many other activities, such as a bandstand used for weekly public concerts during the summer. The above postcard shows a variety of playground equipment for the kids. The below postcard is a view of the two original tennis courts.

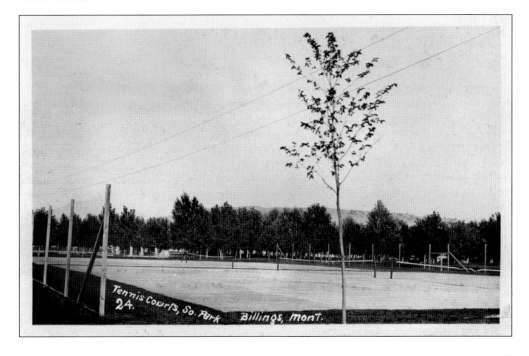

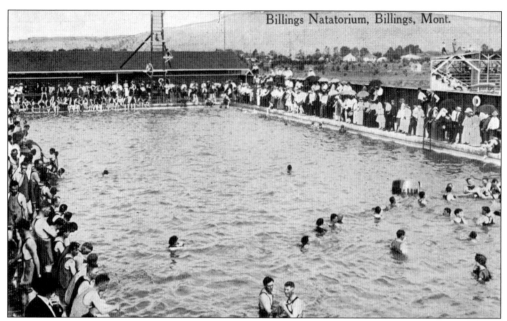

One of the most popular features of South Park is the swimming pool, which is 170 feet long and 62 feet wide. The pool was opened in April 1914 at a cost of $13,000. The postcard shows swimmers of all ages on two sides of the pool with spectators on the other. Swimmers could also make spectacular dives off the diving board. In 1939, the bathhouse was remodeled, and the pool is still making children happy today.

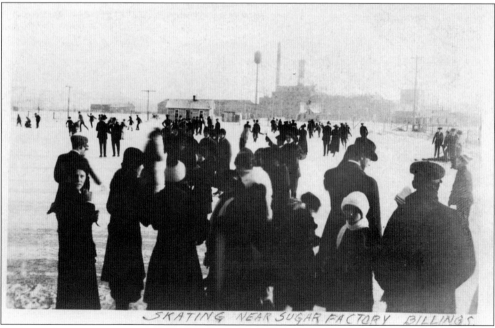

In the early 1900s, Billings was a more leisurely and family-oriented place. This early-1910s postcard shows a large crowd of skaters on the South Park skating rink. The frozen pond had a small warming house, which can be seen in the background along with the 1906 sugar beet refinery.

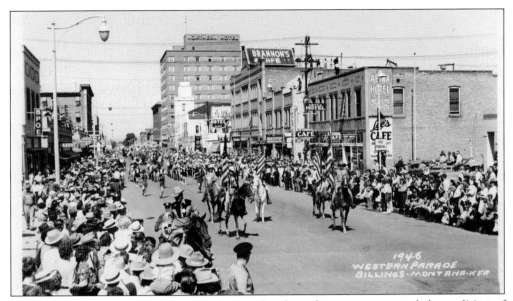

In 1939, the Commercial Club, an early-day chamber of commerce, started the tradition of Western Days to help commemorate the Old West. Billings residents were treated to a western parade followed by several days of rodeos at the fairgrounds. This postcard shows the 1946 western parade heading west on First Avenue. Parade-goers were five and six people deep in the early years. The Northern Hotel can be seen in the background. By the 1990s, the crowds had thinned to the point the Western Days parade was eventually dropped. (KFR.)

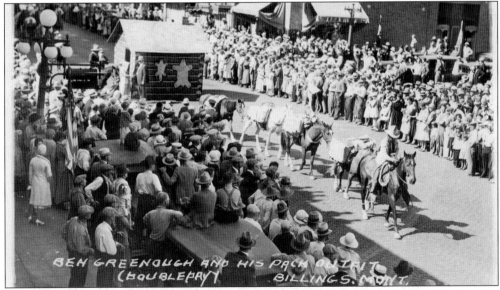

This postcard shows the Western Days parade traveling along First Avenue in front of the old post office. Ben Greenough, packsaddle, is leading his pack train of horses down the street. Ben Greenough is one of Red Lodge's most popular old-time cowpunchers. He was well known for his thick beard and beat-up wide-brimmed hat. Ben moved to Montana in 1886 to work as a cowboy and eventually settled on a homestead north of Red Lodge. He was a friend of Calamity Jane and "Liver Eating" Johnson, who gave Ben the nickname of "Pack Saddle" because he was riding one at the time. (RD.)

71

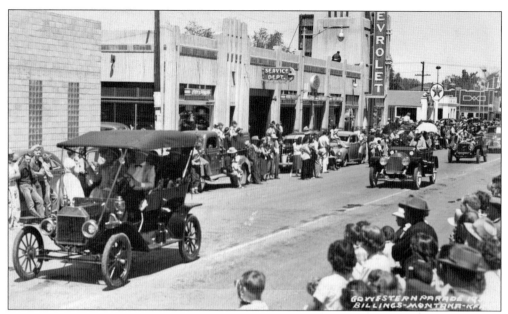

This is a scene of a 1946 Western Days parade traveling west on First Avenue North at Thirty-third Street. Classic autos were always a crowd favorite at the parade. Many of Billings local dignitaries could be seen driving down the parade route wearing vintage clothing. The building in the center background was Lew Chevrolet dealership, located at Thirty-third Street and First Avenue North. After Lew's moved east on First Avenue North, Holiday Furniture eventually took over the building. (KFR.)

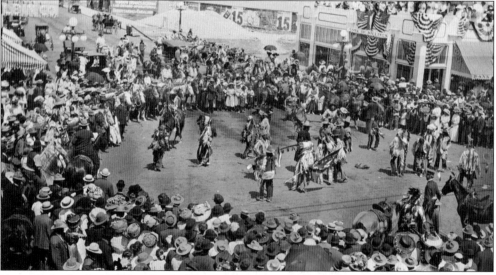

From the beginning, Billings has had a strong American Indian presence. The Native Americans were invited to many celebrations, parades, and rodeos over the years. This 1913 picture was taken at the intersection of First Avenue North and Broadway, where a group of Crow Indians were enacting a ceremonial pow-wow. A large crowd of well-dressed citizens gathered around the Native Americans dancing to the drumbeat wearing their finest costumes. Note that the onlookers were wearing hats of all types. In this early photograph, the whole center of the block was still vacant.

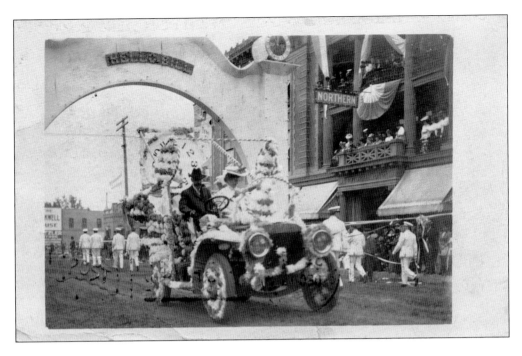

In 1906, the Elks Lodge held their state convention in Billings. Residents came out in the thousands to view a parade with automobiles in it for the first time. The above postcard shows part of the 1906 parade in front of the Northern Hotel. A temporary wood and plaster arch was built to help commemorate the Elks convention. The postcard shows P. B. Moss and his wife, Mattie, driving their decorated 1905 Winston Touring car. The below postcard shows another view of the Elks parade traveling east on First Avenue North, next to the Northern.

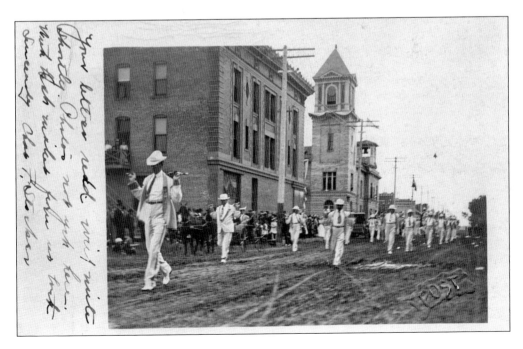

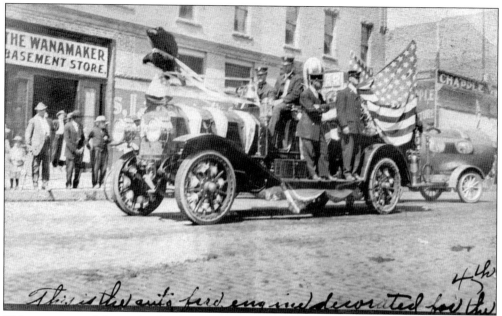

This rare postcard shows the fire department participating in the annual Fourth of July parade in 1911. The firemen are driving the first motorized equipment, the Robinson Hose and Chemical Pumping Engine, which the city purchased in 1910. When the engine was driven over Billings's brick paved streets, the hard rubber tires made the engine feel like it was going to fall apart. The Billings Brewery bottle car can be seen behind the fire engine.

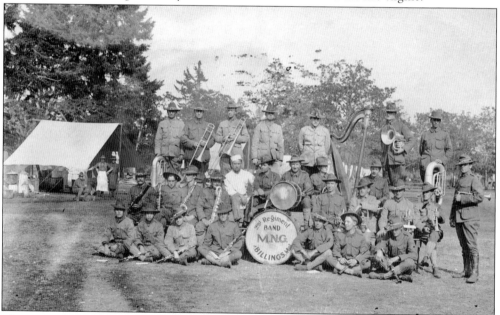

The postcard shows the 2nd Regiment Montana National Guard Marching Band. They were stationed at Fort Lewis, Washington, at the time the photograph was taken in 1910. The harp player would have had a hard time marching with such a large instrument. To the left of the band is a mess tent that looks to be ready to feed the men at any time. The band played in many special events in Billings over the years.

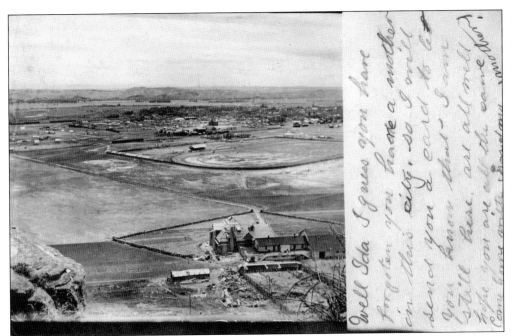

The first Yellowstone Fair opened on September 28, 1892, on 20 acres, which would later become North Park. I. D. O'Donnell was the first president. There was a 1,000-seat grandstand in which fairgoers could view horse racing and rodeos. In 1897, an octagon-shaped building was constructed to house agriculture exhibits. The 1892 state prison (never finished) can be seen in the foreground of the 1907 postcard.

After the fair of 1915, the fairgrounds moved from the North Park area to its present location and was renamed Midland Empire Fair. On September 19, 1916, the new fairgrounds opened with much anticipation. This multi-view card shows the three main buildings on the grounds. The photograph is of the exhibition hall and auditorium, which burned to the ground in 1969. The middle scene is on the grandstand, which was replaced in 1947. The bottom photograph is of the largest horse barn in the Northwest, which still is in use today. (CC.)

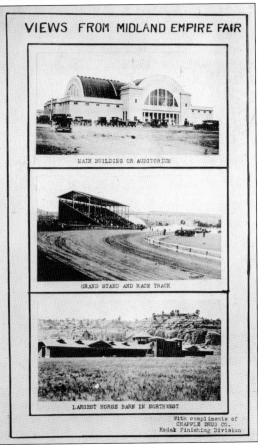

VIEWS FROM MIDLAND EMPIRE FAIR

MAIN BUILDING OR AUDITORIUM

GRAND STAND AND RACE TRACK

LARGEST HORSE BARN IN NORTHWEST

With compliments of
CHAPPLE DRUG CO.
Kodak Finishing Division

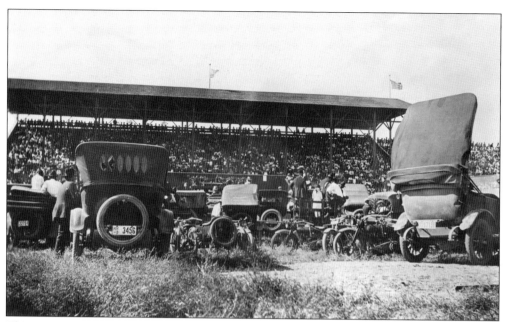

This image, of the grandstands, was taken across the racetrack in 1919. The grandstands were filled to capacity to watch the Billings band give a lively performance. There are four motorcycles and one sidecar in the center of the postcard. In 1919, there were two dealers that sold motorcycles such as Excelsior, Harley-Davidson, Yale, and Indian. In 1947, the old grandstands were torn down and replaced with a larger structure.

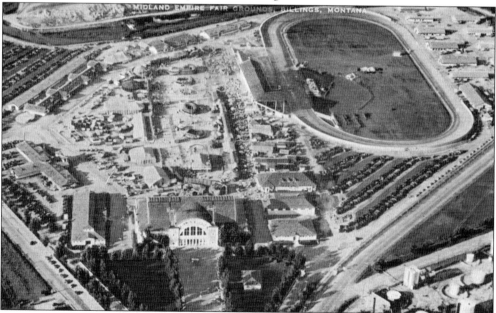

This photograph is an aerial view of the Midland Empire fairgrounds taken in about 1939. Since 1916, the fair has run continuously except for two years during the Depression, 1933 and 1934, and in 1945 during World War II. By the 1930s, a carnival midway was added to the fair (center). The two triangle-shaped parks surrounded by trees can still be seen at the present-day fair. The tanks, on the lower right side of the card, is part of the Yale Oil Refinery. (JKO.)

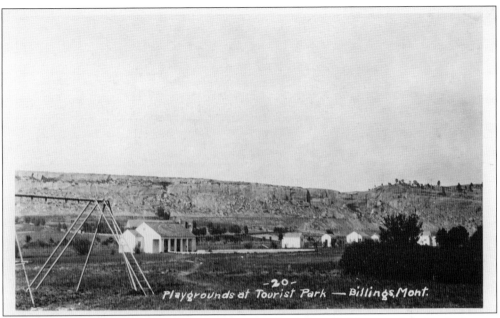

Playgrounds at Tourist Park — Billings, Mont.

This Billings Tourist Park was built on the grounds of the old fairgrounds at Sixth Avenue North and North Twentieth Street. Billings saw the need for a tourist court. In the 1920s, Montana was building an interconnecting highway system to help accommodate the new way of traveling, the automobile. In August 1923, the city opened the 14-acre tourist campground. After three months, 3,190 cars with an estimated 12,000 people stayed at least one night in the park. The tourist park included cabins, a lecture hall, playground, kitchens fully equipped, hot and cold showers, picnic tables, and modern toilets. All these modern conveniences at the auto camp could be had for the small price of 50¢ a night. In 1935, the tourist park closed and most of the equipment and buildings were reused as North Park came into existence.

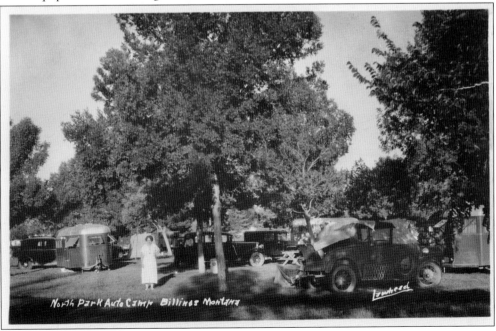

North Park Auto Camp Billings Montana

This is an aerial view of the Billings Tourist Park, taken from on top of the Rims in the early 1930s. Notice all the farmland north of the park, which would later be replaced by residential neighborhoods. The Country Club can be seen in the foreground before it burned to the ground in 1933.

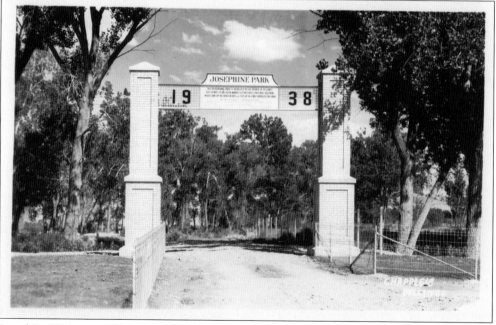

Josephine Park opened in June 1938, along the Yellowstone River next to the water treatment plant. The park was named in honor of the river steamer *Josephine*, which reached the site of the park in 1875. This was the highest point reached by any steamer boat on the Yellowstone. After being a popular picnic area for over 30 years, the park was closed.

Six

INDUSTRY,
TRANSPORTATION

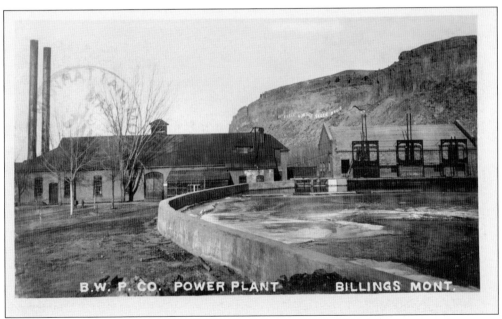

In 1885, Billings Water and Power incorporated with $60,000 to build a plant near the present water treatment plant. On January 29, 1887, the lights and water were turned on in Billings for the first time. The huge two-story pump could handle a million gallons a day, which turned large dynamo producing electricity. In 1912, Billings Water and Power was sold to the Montana Power Company of Butte. During the power plant's earliest years, power was only produced during the evening because it only supplied electricity for lights.

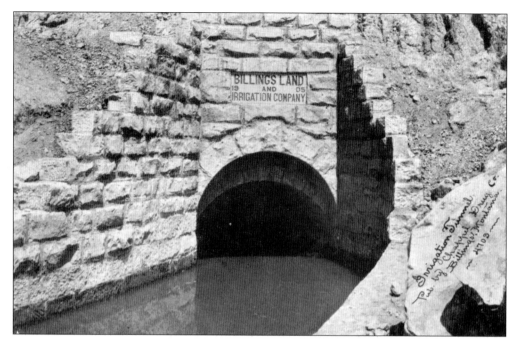

In 1903–1904, the Billings Land and Irrigation Company (BL&I) was incorporated and started to build a canal to bring water to the Billings western farmlands and the Billings Bench "Heights." By 1905, the canal was 52 miles long and 40 feet wide. It carried water to 25,000 acres of farmland. BL&I sold land for $35 per acre in 1904, and after the canal was built, the same land was fetching $50. In 1915, BL&I sold out to the owners of the bench land and the new organization was called the Billings Bench Water Association, still around today. (Above, CC; below, HW.)

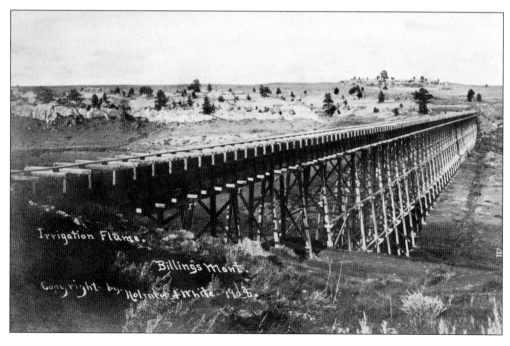

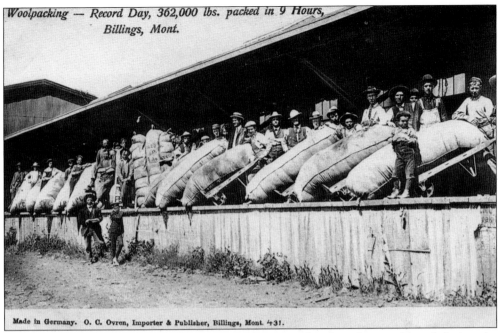

Woolpacking — Record Day, 362,000 lbs. packed in 9 Hours, Billings, Mont.

Made in Germany. O. C. Ovren, Importer & Publisher, Billings, Mont. 431.

As early as 1893, Billings reported that 3 million pounds of wool were shipped during the year. By 1907, the pounds of wool shipped had risen to 15 million. The 1908 postcard shows the Northern Pacific Wool warehouses located on South Twenty-seventh Street next to the railroad tracks. The postcard reads, "Record day 362,000 lbs packed in 9 hours. Each sack contained about 100 pounds of wool." (OGO.)

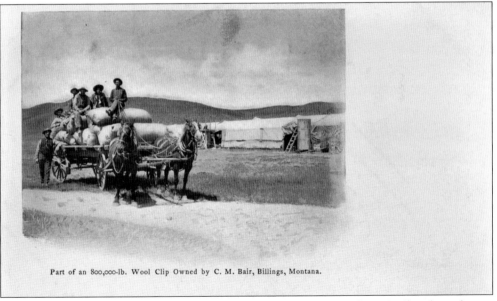

Part of an 800,000-lb. Wool Clip Owned by C. M. Bair, Billings, Montana.

Charles M. Bair (1857–1943) came to Montana in 1883 as a Northern Railroad conductor. By the 1890s, he had become a well-known sheep man. At one time, he owned over 25,000 sheep on his ranch near Martinsdale. The postcard shows "part of an 800,000 pound wool clip owned by C. M. Bair Billings MT" in 1906. In 1910, Bair shipped 47 railroad cars filled with 1.9 million pounds of wool.

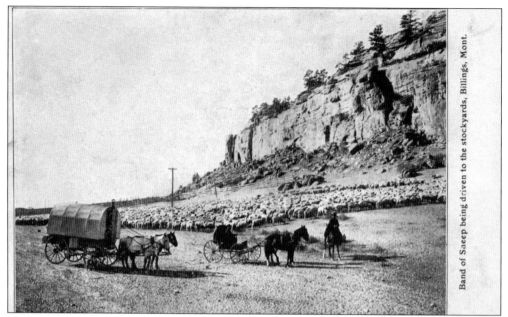

Band of Sheep being driven to the stockyards, Billings, Mont.

This 1910 postcard shows a band of sheep being driven west on what would become Sixth Avenue North near the fairgrounds. The message on the back of the postcard tells the story of many Montana sheepherders: "I don't like it very well on the sheep ranch because them sheep bellered so much that I couldn't hear myself think besides that I had to do my own cooking and washing and sleep in a wagon as you see on the other side of this card." (MPC.)

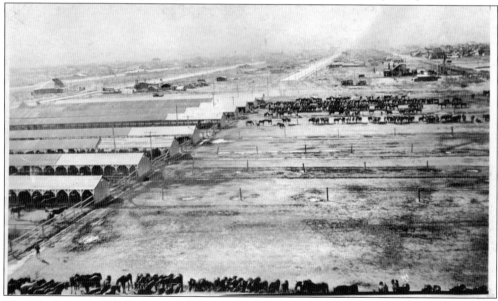

The Northern Pacific Stockyards were located just south of First Avenue North near the fairgrounds. In the late 1800s, between 15,000 and 25,000 head of cattle were being shipped out of the stockyards every year. By the 1920s and 1930s, Billings was importing more cattle than exporting. The city had built two major meatpacking plants, Pierce Packing Company and Midland Empire Packing Company. Billings was believed to be the largest packing center between Fargo and Spokane.

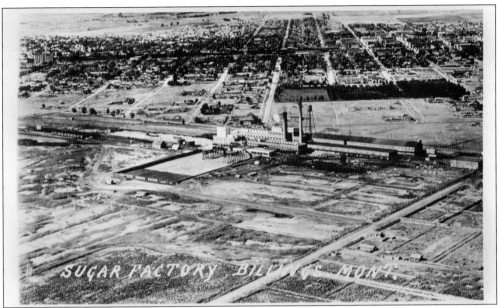

In 1906, I. D. O'Donnell (1860–1948) and several other leading businessmen were involved in building the sugar beet refinery in Billings. The plant was called the Billings Sugar Company. The million-dollar factory was designed to process 55,000 tons of contracted sugar beets grown on over 50,000 acres of land. This aerial view of the refinery is looking north from behind the factory located on State Avenue. The three blocks of tree-lined South Park can be seen in the background.

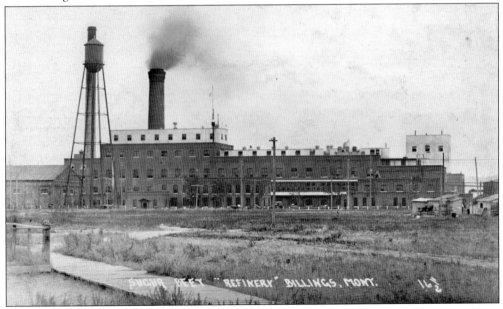

By 1913, the Billings Sugar Company harvested over 23,000 acres of beets worth $2.5 million. In 1918, the Great Western Sugar Company acquired the plant, reported to be one of the largest in the United States. The above view shows the front of the sugar refinery from about 1910. On the lower left side of the card, one can see the wooden sidewalk, which ran from South Park to the refinery.

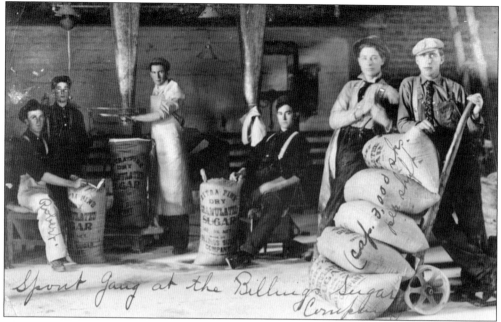

This rare early interior view from January 1909 shows six workers at work in the sugar refinery. The caption reads, "Spout gang at the Billings Sugar Company 3,000 sacks per shift." According to the message on the back, Robert, on the extreme left, was a sack sewer at the sugar factory. After the 100-pound sacks were filled, they were hand-loaded into freight cars.

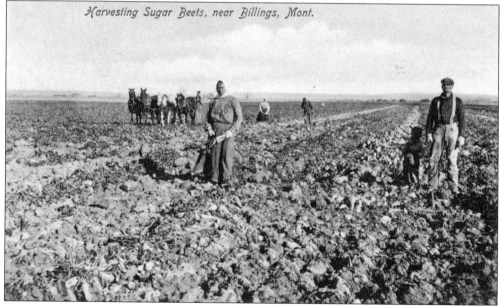

In 1910, harvesting sugar beets was a labor-intensive job. Before the 1930s, when machinery was first used, workers would have to use a team of horses to plow and uproot the sugar beets. Migrant workers would then hack the beet tops and throw them into farrows for later pickup by wagon. Weeding and harvesting beets was recorded by several waves of immigrants. First came the Japanese, then the Germans, and starting in 1923, the Mexicans. The above postcard shows a German family harvesting beets with their two young children. (AIC.)

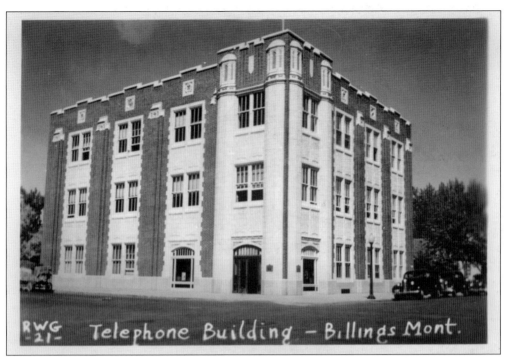

Telephone Building – Billings Mont.

In 1895, Billings installed one of the first two-party telephone systems in Montana. The Mountain States Telephone and Telegraph Company (MSTTC) formed in 1914 to provide phone service in the Billings area. In the late 1920s, a transcontinental telephone line was routed through Billings. The MSTTC moved to its new building on Second Avenue North and Thirtieth Street in 1931. The above postcard shows the new building. (RWG.)

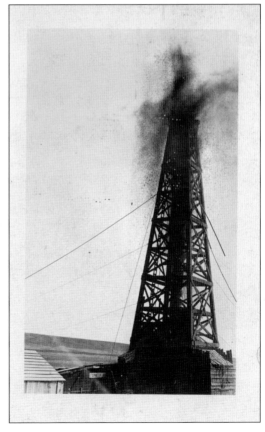

The Hepp Well, located in the Lake Basin, was one of the first nearby oil strikes in Montana on May 12, 1924. The message on the back reads in part, "This is our big well. It throws gas and oil 80 feet high out of a six inch pipe at a rate of 1500 barrels per day. We use gas in Billings Cash from 50 cents to $1 per week to run day and night."

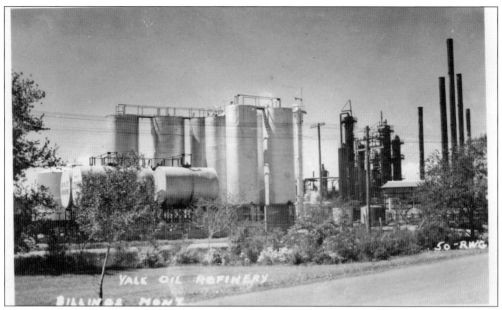

One of the first oil refineries in Billings was built by the Yale Oil Company in 1929. The company erected a 2,000-barrel plant at a cost of $100,000 just south of the present fairgrounds. The refinery expanded several times over the years to keep up with demand. Most of the oil to be refined was piped in from the northern Wyoming oil fields. Their most popular brands of products were Handcock oils and Litening gasoline. In 1944, the Yale Oil Company was sold to the Carter Oil Company. Currently the oil refinery is owned by Exxon in Lockwood. (RWG.)

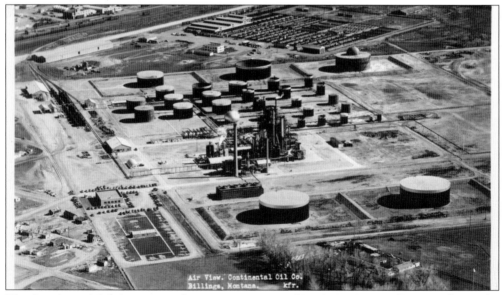

The Continental Oil Company refinery was constructed in 1949 at a cost of $9.45 million. The refinery had a capacity to process 11,700 barrels daily. Most of the oil to be refined came from Frannie in the Elk Basin fields in Wyoming. In the late 1960s, the Continental Oil Company changed its name to its parent company Conoco. The postcard shows the newly constructed refinery located southeast of Billings. The Billings stockyards are in the background. (KFR.)

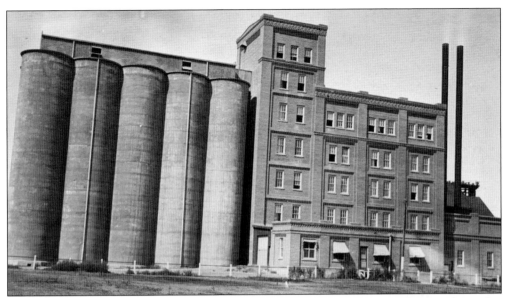

The Russell-Miller Milling Company opened a large brick mill and elevator in 1910 located at 3620 First Avenue South. They bought out A. L. Babcock's Yellowstone Valley Mills, which produced Billings Best Flour. The Minnesota-based company sold flour under the name Occident, meaning "out of the west."

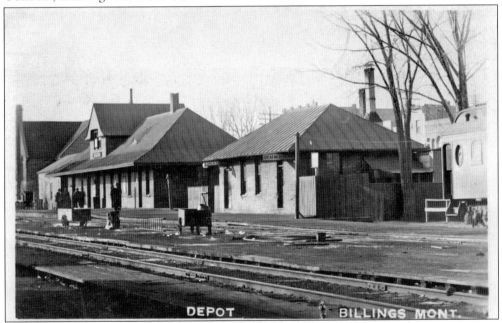

Early in Billings's life, Herman Clark, manager of the Minnesota and Montana Land and Improvement Company, promised to build a $50,000 railroad depot, but the plans never fully materialized. Meanwhile, passengers were unloaded at the Head Quarters Hotel, which served as a depot until it burned in 1891. The postcard shows the 1892 depot located across Broadway at the railroad tracks. When the depot was built, the size was more than adequate. Billings only had a population of 836 in 1890, but by 1910, it had reached 10,031, making the depot undersized. The small building to the right is the dining hall.

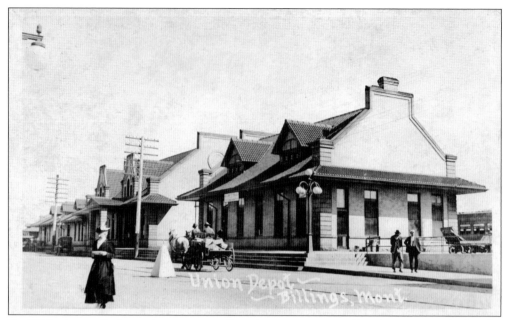

By 1900, the small depot that sat across Broadway was too small and a new one had to be built. On March 24, 1909, the new depot was used for the first time by the Northern Pacific Burlington Line. This mid-1910s photograph shows the Northern Pacific lunchroom in the foreground with ticketing, waiting room, and baggage in the second building. In the early days, 24 trains would stop in Billings.

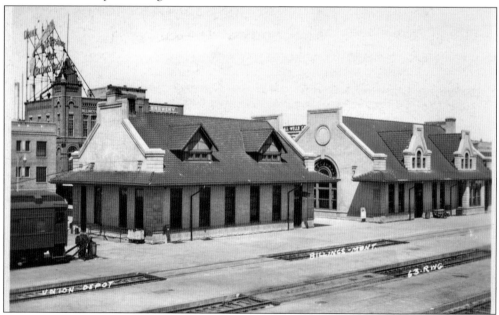

This postcard shows the south side of the union depot in the early 1940s. During the early years, there were four sets of tracks in Billings to handle the large amount of traffic going in either direction. By the 1960s, cars and trucks had taken over the main mode of shipping and transportation. In the late 1970s, the depot was abandoned. In the background is the Billings Brewery with its 2,000-bulb twinkling sign that said, "Drink Old Fashion Beer Billings Bry Co." (RWG.)

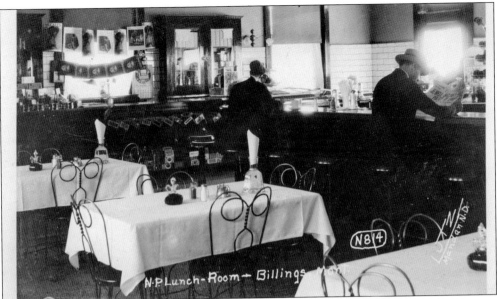

Built in 1909, the lunchroom was a very busy place at times. Trains had a scheduled layover while in Billings. Passengers had a short time to relax and get a bite to eat. Some layovers were longer so passengers could explore more of the city, according to the messages written on the back of several postcards. The postcard shows several very clean tables and a well-stocked counter full of magazines, cigars, postcards, and even Cracker Jack. The lunchroom was closed in 1965. (LUTZ.)

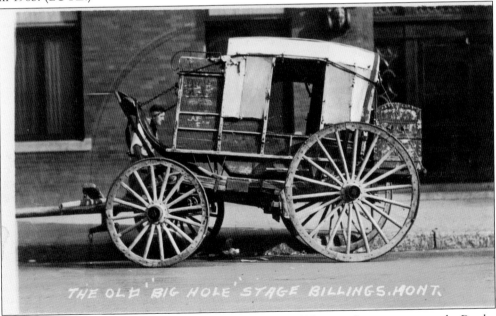

This postcard shows the old "Big Hole Stage," which could be seen for many years at the Rocky Campus. The stage was in service in the Virginia City and Sheridan areas. The word "Hole" was a term used to describe a basin or valley that had been cut for a riverbed in past ages. The Battle of Little Big Hole was fought here in August 1877, when Gen. John Gibbson fought the Nez Perce in the Big Hole Basin. Chief Joseph withdrew and took flight across Montana.

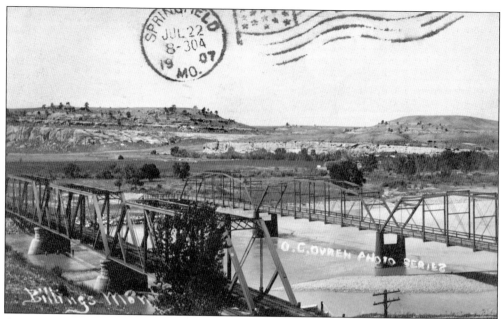

Construction began in 1881 on the single-span railroad bridge (left) and was finished several months before the Northern Pacific reached the Yellowstone River in August 1882. The East Bridge on the right was the first steel and wooden wagon bridge built on this site in 1907. Before this bridge was built, people would have to use a rope ferry to cross the Yellowstone River. Over the years, both bridges have been replaced several times. The farmland behind the bridge is the permanent site of the Billings fairgrounds.

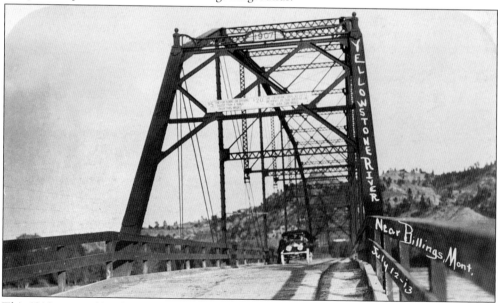

This 1913 postcard is a head-on view looking east of the East Bridge that was built in 1907. Part of it collapsed in 1910 when too many cattle at one time were driven across the bridge. In 1935, a steel and concrete bridge replaced the old East Bridge. The sign over the bridge reads, "Five dollar fine for riding or driving faster than a walk over this bridge and $20.00 fine for driving over 30 head of cattle or horses or 200 sheep at one time over this bridge."

In the early days of Billings, pedestrians would grumble every time it rained because the city streets would turn into a muddy mess. The only thing that kept citizens out of the mud and filth was a wooden walkway across the street, which was known to sink over time. Between 1910 and 1912, a group of skilled bricklayers started to pave the streets of downtown Billings. A horse-driven water wagon was used to clean and keep the dust down on the city streets.

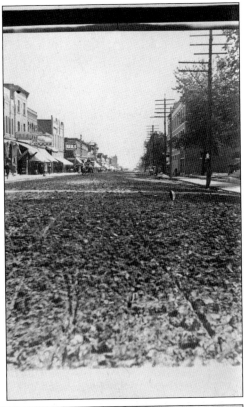

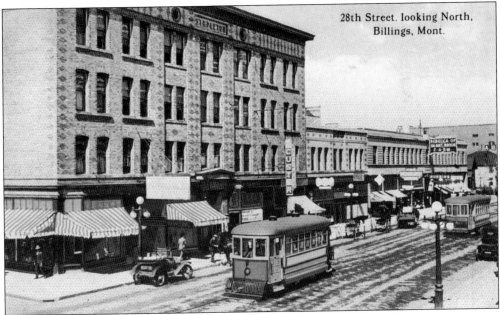

28th Street, looking North, Billings, Mont.

This 1914 postcard is looking down Broadway in front of the Stapleton Building. Two streetcars are traveling south. A total of six battery-powered, yellow and red Edison Beech streetcars went into service in 1912. They traveled on a 6-mile track throughout Billings and cost 5¢ for a ride. In 1917, the streetcars were discontinued. (PONS.)

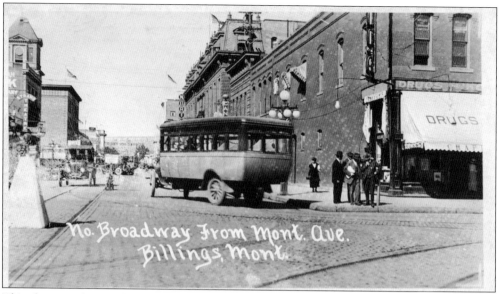

This photograph was taken at the intersection of Montana Avenue and Broadway looking north. It shows the first motorized mass transit in Billings. In 1923, the Pioneer Transit Company started shuttling citizens around Billings and provided service to Roundup and Lewistown. In 1944, the Western Transit took over the operation until the Billings Motor Coach took over service in 1967. In 1972, the METropolitan Transit was started by the city and continues to provide great service. (CC.)

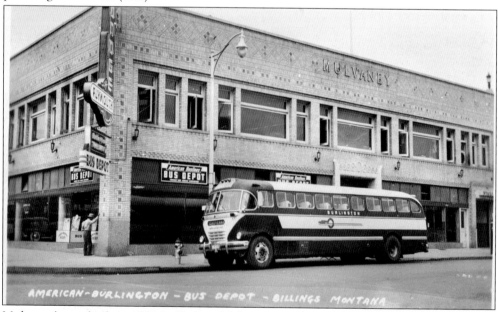

Mulvaney's was built in 1926 by Robert Mulvaney at the corner of Twenty-sixth Street and First Avenue North. The dealership carried several makes of automobiles, including Wippets, Willys-Knight, and Plymouth. After 1929, they mainly sold Dodges and Plymouths. The first bus terminal in Billings could also be found in Mulvaney's. Passengers could travel by Burlington Trailways or Greyhound bus. The building was razed in the mid-1970s for a parking garage. (RWG.)

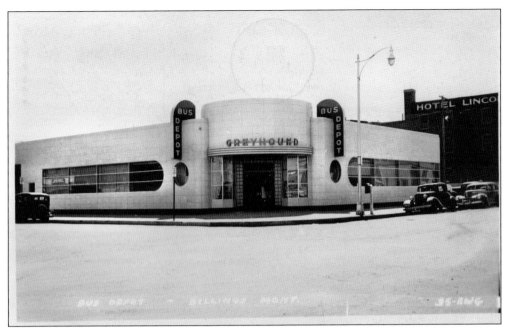

As the interstate highway system improved during the 1930s and 1940s, the bus became a better way to travel. The first bus depot was located in the Mulvaney Building at 2605 First Avenue North. The Burlington Trailways and Greyhound were the two main carriers. In 1943, the present Greyhound bus depot at 2502 First Avenue North was built in the late art deco design.

Dr. Frank Bell, a dentist, was an early-day hero to many kids in Billings. On Memorial Day 1913, he flew his open-frame Curtiss O-X-F biplane from Billings to Laurel and Pak City and back. It was the longest flight made in Montana until 1916. Bell took off from a vacant lot at the north end of North Twenty-seventh Street. This postcard shows a 1913 flight over South Park during the opening of the new park.

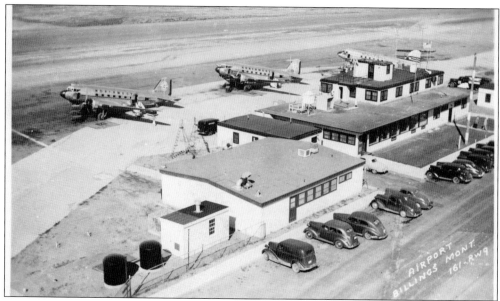

The City of Billings obtained an option to buy 400 acres at $5,188 to build an airport on top of the Rims. Dick Logan (1890–1957) was the first Billings Municipal Airport manager from 1927 to 1957. He had a horse ranch northeast of the airport. During the early years, he graded the landing strips himself with a team of horses. In 1935, the first terminal building and hangar was dedicated. By 1940, the terminal was expanded several times and two more hangars were built. Late in the 1950s, Northwest Airlines was the main passenger service provider. (RWG.)

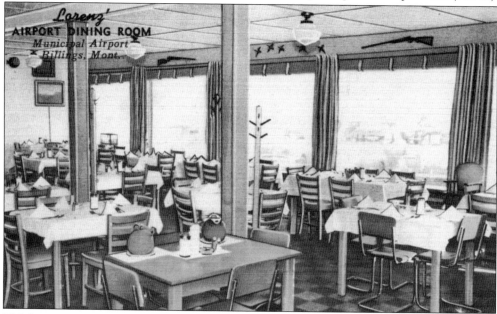

This late-1940s interior postcard view shows Larenz's airport dining room with its unsurpassed view of the three mountain ranges in the distance overlooking the Yellowstone River Valley and the city of Billings 500 feet below. In the 1960s, the name was changed to the Skyview Terrace, which was known for its great steaks. The dining room was originally opened in 1935 by Dick Logan's wife, Marge. (WASC.)

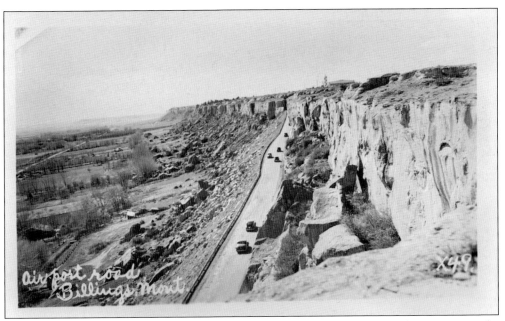

Before 1930, there were only three ways to reach the top of the Rims. One way was to go to the fairgrounds around Boot Hill and up the back side of the Rims. Second, in 1910, Haffner's Quarry employees carved steps into the side of the Rims above Montana State University, Billings. The third way was by the Zimmerman Trail. After the airport site was chosen, the city officials decided that a new and more convenient way to get to the top was needed. The airport road was constructed between 1932 and 1935. Work was slow going because huge sandstone boulders had to be blasted. In the mid-1960s, the two-lane Airport Road was finally widened to accommodate heavier traffic volumes. The above postcard is looking up Airport Road in the 1940s. The left side of the card shows how little the Rimrock Road area had been developed. The postcard below is a view looking down Airport Road with downtown Billings in the distance.

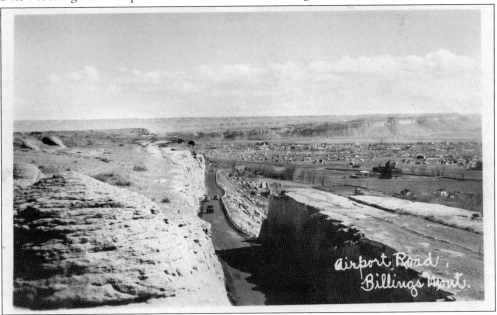

The Custom Tire Company was started by Fred Cloud and Kenneth Allen in about 1936. The postcard shows the tire store at its first location at 3115 First Avenue North. It advertised B. F. Goodrich tires for sale, and recapping was a specialty. Custom Tire went out of business in 1961. (KBI.)

Howard O'Loughlin opened his standard service station at 2110 First Avenue North in 1940. In 1927, there was 17 filling stations in Billings, and by 1949, there were over 50 stations. O'Loughlin closed this station after 27 years at this location.

Seven

GOVERNMENT BUILDINGS, SCHOOLS

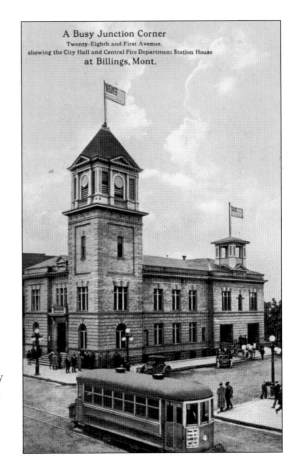

A Busy Junction Corner
Twenty-Eighth and First Avenue,
showing the City Hall and Central Fire Department Station House
at Billings, Mont.

This is a postcard of the first permanent city hall built on the corner of Broadway and First Avenue North. On April 1903, the city hall was formally dedicated and cost Billings residents $32,000. The Maverick fire department had its station in the rear of the building. (PONS.)

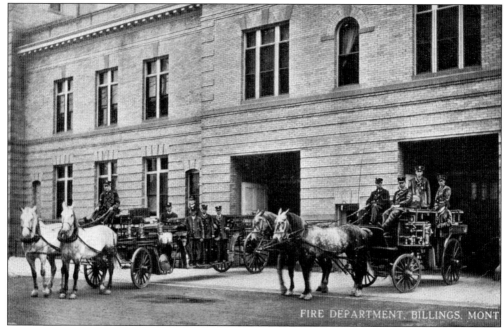

The Maverick Hose Company was stationed in the back of city hall facing First Avenue. Started in 1889, the Mavericks were a volunteer fire department that eventually became a paid fire department by 1914. Until 1910, the fire department only had horse-driven engines to combat fires. The above postcard shows two early-day types of fire engines. (BB.)

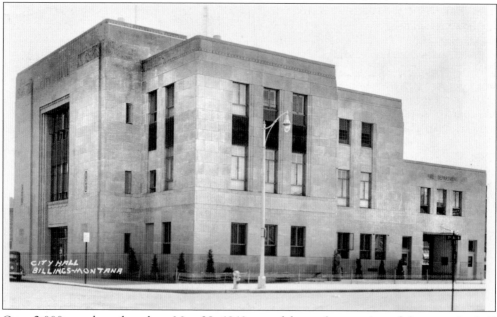

Over 2,000 people gathered on May 28, 1940, to celebrate the opening of the new city hall at Twenty-seventh Street and Third Avenue North. The building was finished at a cost of $215,000, and its architecture was considered modern functional. In the rear of the building was the fire department and police department. The second floor was reserved for courtrooms and jail. (KFR.)

In 1905, a new Yellowstone County Courthouse was built at a cost of $125,000 on the east side of North Twenty-seventh Street between Second and Third Avenues. The top floor held the jail and courtrooms, and the bottom two floors were reserved for county offices. The building was complete with a bell tower and clock. The clock would have to be reset often because pigeons would perch on the clock hands. For 53 years, the old courthouse served Yellowstone County well. The above postcard shows a large gathering of people in front of the courthouse in the fall of 1918. The postcard at right shows the courthouse in the mid-1930s. (Above, Crosby; right, J. J. Petek.)

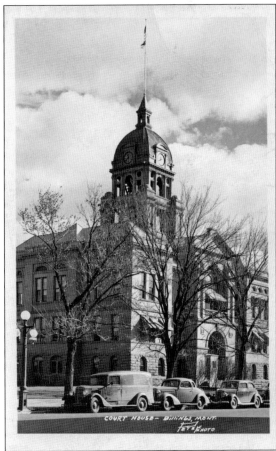

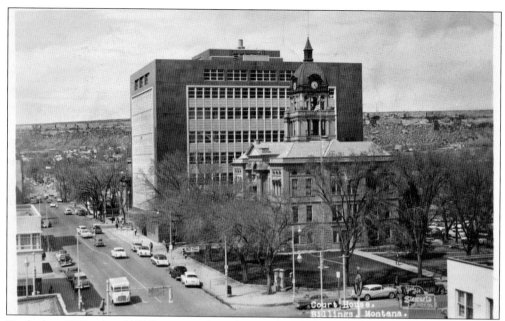

By the late 1950s, the old Yellowstone Courthouse was becoming overcrowded and unsafe. The new $1.5-million building was completed in 1958, just north of the old courthouse. Before the wrecking ball demolished the old courthouse in 1958, the two buildings sat side-by-side for a few months. Today there is a park and veterans memorial wall where the once stately building stood. (KFR.)

The Yellowstone Art Center (YAC) opened in 1950 on the top floor of the Commercial Club building. In 1962, a new jail was opened and the old Yellowstone County jail was put up for sale. The art center conducted a successful fund-raiser and was able to buy the 1913 jail. In 1964, the YAC moved into its new building. (KFR.)

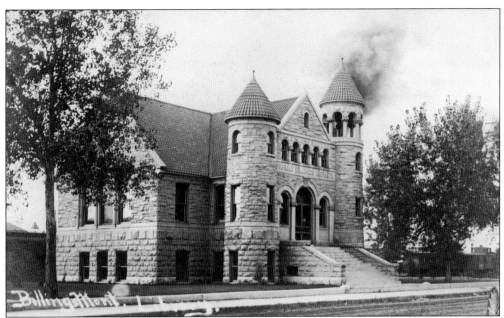

Upon the death in 1888 of Parmly Billings, Frederick Billings's oldest son, the Billings family donated $25,000 toward a library to be built in Parmly's name. In 1901, the Parmly Billings Memorial Library was built at 2822 Montana Avenue. Michael A. Jacobs, stoneworker from Columbus, was one of the skilled artisans who turned raw sandstone into beautiful columns and arches. The library opened with 2,456 books and employed Mabel Collins as the first librarian. In 1911, Frederick Billings Jr. gave $11,000 to build an east wing to the library. Elizabeth Billings gave $20,650 for a west wing in 1923. In the late 1960s, the library moved to its present location at 510 North Broadway. In 1971, the old library became the Western Heritage Center Museum.

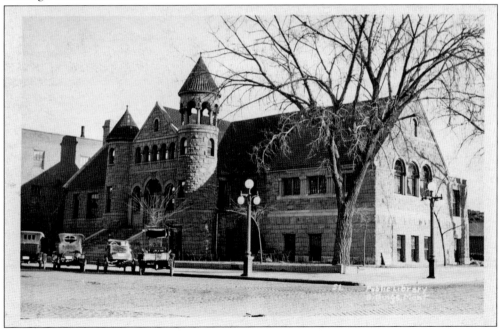

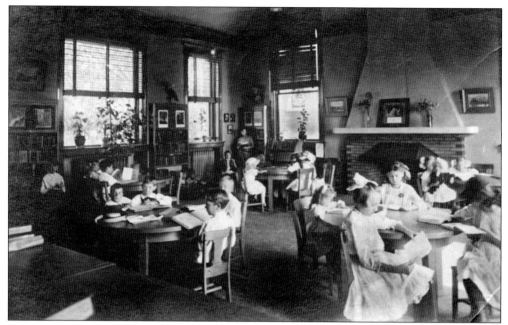

This is a rare postcard that shows the interior of the children's wing at the Parmly Billings Memorial Library. In 1911, Frederick Billings Jr. gave $11,000 to add an east wing to the library, used for a children's reading room. This postcard was sent to Maukato, Minnesota, in 1913 by Mabel Collins. She was the first librarian in Billings.

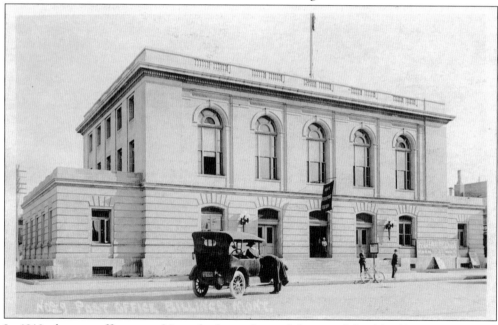

In 1913, the post office moved into the lower floor of the new federal building at 2604 First Avenue North. In that same year, Charles Goddard started the first parcel delivery. He used a modified motorcycle and drove on sidewalks to stay out of the mud until the first truck was purchased in 1918. Just before World War I, the 20 Billings postal employees earned $50 a month, and by 1940, wages rose to $175.

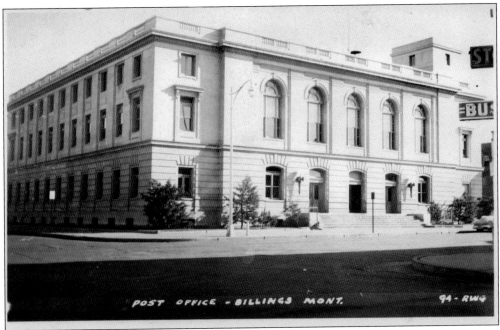

In 1933, the post office temporarily moved into the Mulvaney Building while the second–floor space and addition to the south were added to keep up with Billings's growing demands. By 1940, a third floor was added and the building enlarged. In 1978, the sorting operation was moved to the present location on Twenty-sixth Street and Eighth Avenue South. (RWG.)

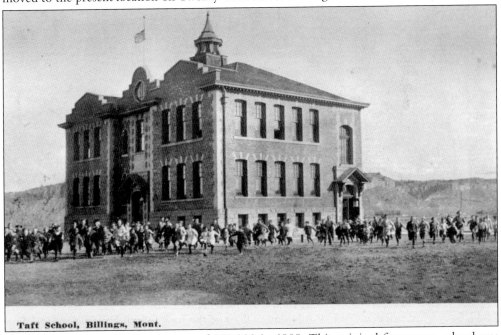

Taft Elementary was built at a cost of $25,000 in 1909. This original four-room school was located at the corner of South Twenty-sixth Street and Sixth Avenue South. In the early 1960s, it was torn down for a new modern school. The students look like they are having fun running toward the cameraman. (PONS.)

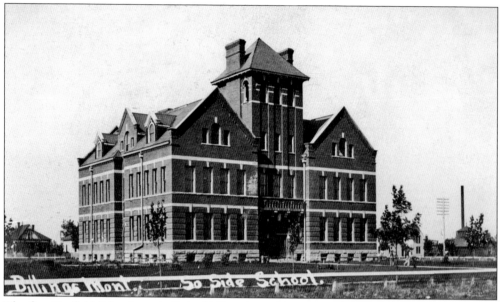

The first Garfield School was built in 1902 and was located at First Avenue South and Thirty-second Street. It was equipped with a third-floor gymnasium, the first for schoolchildren in Billings. Emergency evacuation was by a cylinder slide fire escape with outlets on the second and third floors. As a reward for having perfect attendance, a class would be permitted to exit down the fire escape. In the mid-1930s, the present Garfield was built next to the old one, which was eventually torn down.

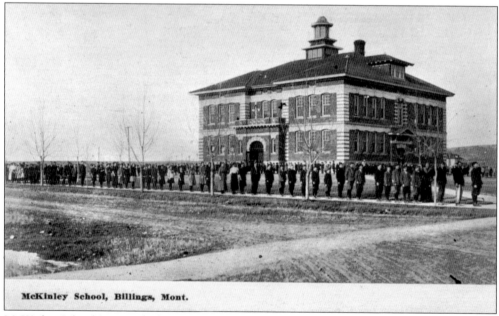

McKinley School is named after Pres. William McKinley, who was assassinated in 1901. The school, built in 1906 at a cost of $25,000, is located at North Thirty-first Street between Eighth and Ninth Avenues North. This is the oldest continually used school in the district. McKinley originally had only eight classrooms until its 1917 addition of six classrooms, with 461 pupils attending.

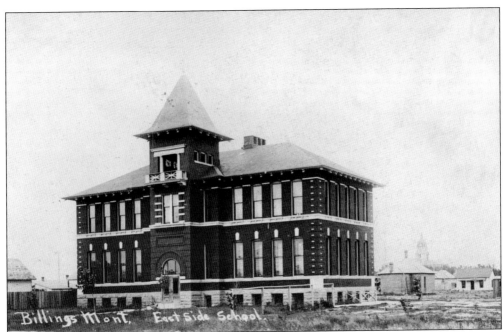

In 1905, Roosevelt Elementary was completed. It was built with four rooms originally, with an addition added in 1907. The school had one of the first kindergartens in Billings. In 1939, Roosevelt was replaced by North Park School and sold to Yellowstone County. The old school was used as the county welfare and extension office until it fell to the wreckers.

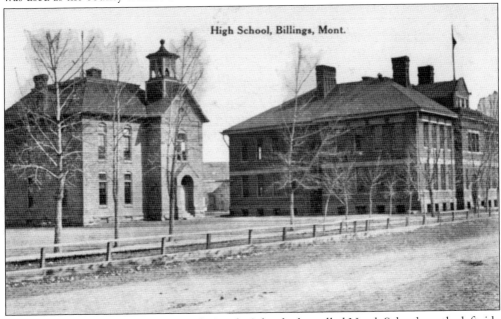

This 1909 postcard shows the original Lincoln School, also called North School, on the left side of the card and Jefferson High School on the right. The first permanent school building, North School was completed on Fourth Avenue and Twenty-eighth Street at a cost of $14,000 in 1884. Frederick Billings donated most of the money for the school. In 1900, Billings residents approved a $15,000 bond to build its first high school, named Jefferson. (PONS.)

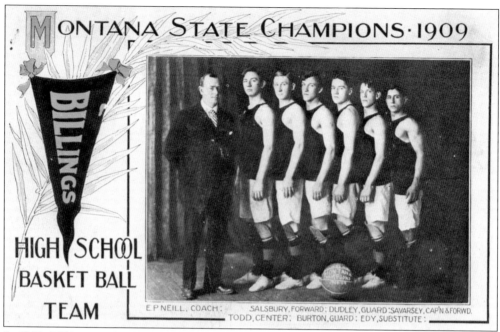

MONTANA STATE CHAMPIONS·1909

BILLINGS HIGH SCHOOL BASKET BALL TEAM

E.P.NEILL, COACH: SALSBURY, FORWARD: DUDLEY, GUARD: SAVARSEY, CAP'N & FORWD.
TODD, CENTER: BURTON, GUARD: EDY, SUBSTITUTE:

In 1905, Billings High School played its first season in boys' basketball. By 1909, the boys won the Montana State Championships for the second time. This team went on to be the forerunner of the Billings Basketball Boosters, or Triple Bs, Team, one of the best in the country during 1909–1914. The team had E. P. Neill as coach. The Triple Bs Team won 95 percent of 350 games from 1909 to 1916 in either professional or amateur categories. (MPC.)

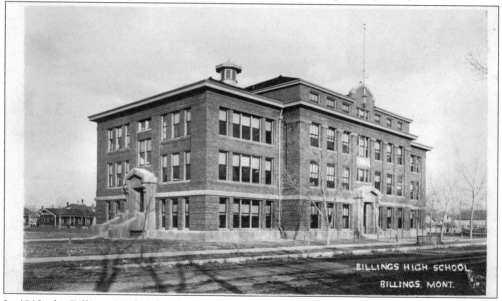

In 1913, the Billings High School was opened on the corner of North Thirtieth Street on the same plot of land as North School and Jefferson High School. In 1921, the back addition was built followed by an expansion in the front in 1928. The Jefferson school was torn down in 1935 to make way for a new auditorium. The building became Lincoln Junior High School when the new Billings Senior High was constructed in 1939.

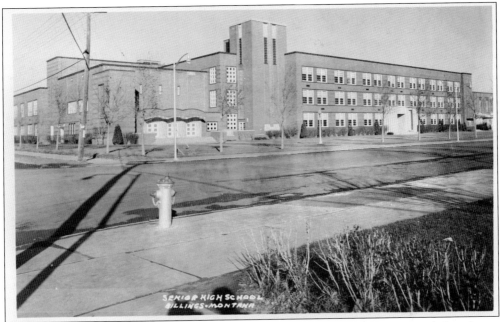

During the 1930s, the downtown Billings High School was drastically overcrowded, so it was apparent a new school had to be built. The 1929–1930 statistics show there were 1,109 high school students, and by 1938–1939, there were 1,848, an increase of 66.6 percent. In 1939, the Billings Senior High School was built on Grand Avenue at a cost of $1 million. The new 52-room high school was expected to care for 1,300 students with a capacity of 1,800. (KFR.)

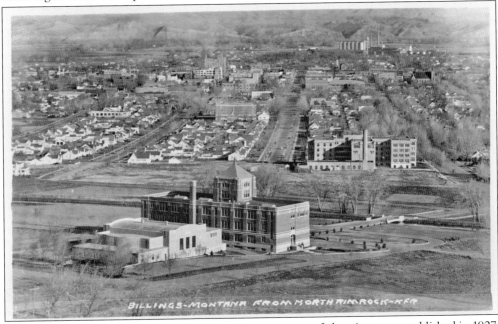

Eastern Montana Normal School (EMC), after seven years of planning, was established in 1927. The college opened on September 12 of that year, admitting 140 women and 9 men. Pres. Lynn B. McMullen led a 14-member faculty. Classes were held in various buildings belonging to the Billings Public School System until McMullen Hall was built in the mid-1930s. (KFR.)

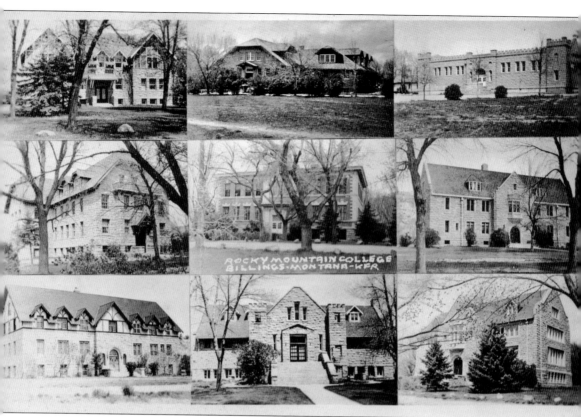

Polytechnic (Rocky) was founded by two ambitious brothers, Ernist T. and Lewis T. Eaton, in 1908. The campus was started by several youths who cleared a sugar beet field and then dug excavations and stones from the Rimrocks for the early buildings. The college offered courses in commerce, engineering, agriculture, and music. In 1935, Helena's Intermountain Union College was looking for a new home because an earthquake destroyed their campus. By 1947, the two schools came together to form Rocky Mountain College. The buildings in the postcard are, from left to right, (first row) Alden Hall, Prescott, Common, and Losekamp Hall; (second row) Kennedy Hall, Administrative Building, and Tyler Hall; (third row) Kimball Hall, Technology Building, and Gymnasium. (KFR.)

Eight

HOMES, CHURCHES

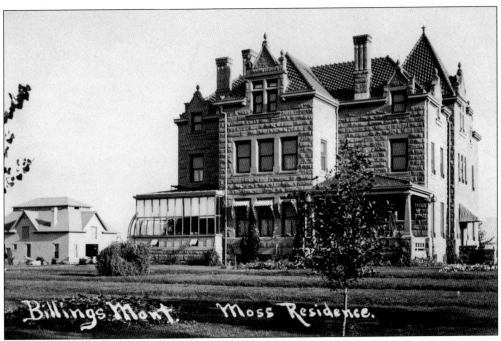

Preston Boyd Moss (1863–1947) came to Billings in 1892 in search of buying into a bank, the First National Bank. P. B. Moss started to build his $105,000 house in 1901 at 914 Division Street. It was finished two years later with a 300-guest open house. The architect for the house was H. J. Hardenberg, who designed the original Waldorf-Astoria Hotel in New York City. The French Gothic–style house is made of red-brown sandstone quarried from the Lake Superior area. In the back of the house, there was a barn and carriage house. Moss's daughter, Melville, lived in the house until her death in 1984. In 1986, the house was turned into a museum.

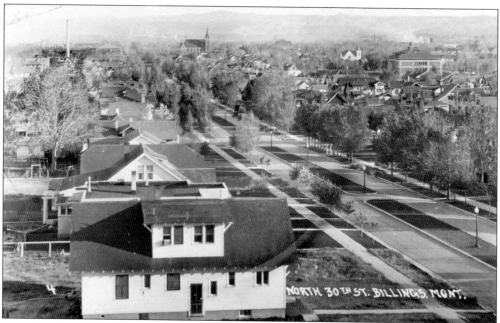

In the early 1900s, Billings residential areas started to grow rapidly to the north of town. The new subdivision was called North Side. It ran from Ninth Avenue North to Twelfth Avenue North and Thirtieth Street to Thirty-second Street North. Most of the houses in this area were built by business owners, doctors, lawyers, and well-established employees. The new subdivision came up with the idea of beautifying the street with wide boulevards in the middle. The two postcards on this page were taken from St. Vincent's looking south during the early 1920s. The card above shows the McKinley school in the upper right side of the card along with St. Patrick's Co-Cathedral. The card below shows the development of Avenues A through D to the right of the picture.

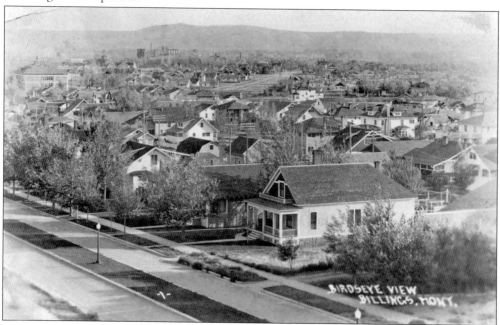

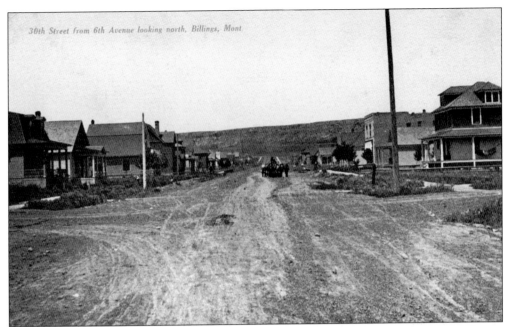

This 1908 postcard shows a residential street looking north on Thirtieth Street from Sixth Avenue. The two-story brick building in the right background was Rich McMutt's North Side Cash Grocery. Today the two-story brick building and a few houses are left because of hospital and business expansions. (TJ.)

This beautiful Spanish-style house can be seen at 439 Grandview Boulevard. It was built in 1943 for Harry H. Gullard, who was a local investment banker. Over the years, the house was enlarged several times and the outer wall heightened. The house is located on the corner of Poly Drive and Virginia Lane. (RWG.)

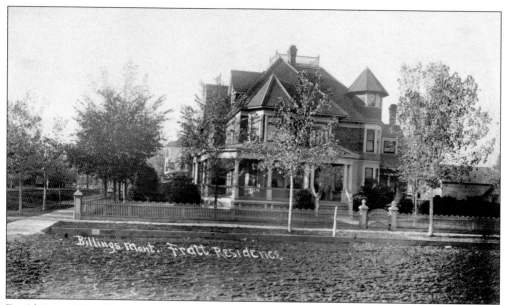

David Fratt (1840–1912) reached Virginia City, Montana, in 1864 and tried his luck in mining. By the mid-1880s, he bought a large cattle ranch north of Lavina and eventually became vice president of the Yellowstone National Bank in 1895. Fratt built a lovely frame house at 205 North Twenty-ninth in 1899. After David and Kate Fratt died, the house was moved in sections to its present location, 142 Clark Avenue for J. G. Link, architect of the David Fratt Memorial Building. The memorial building was constructed on the original site of the house. (HW.)

The house was built at 43 Yellowstone Avenue in 1906 for Mr. and Mrs. M. A. Arnold. Over the years, the house had a host of owners. One of the longtime owners of the house was E. H. Walrath, who was in the grain elevator business. The house has a wide front porch, and the balcony is supported by 12 columns. In the back of the house is a red-painted framed carriage house.

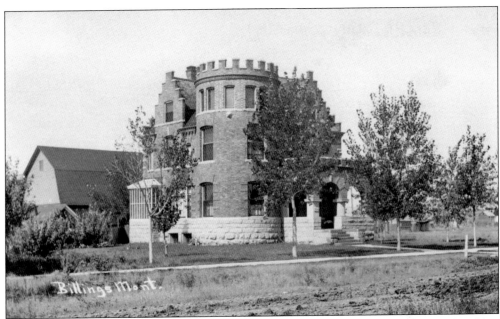

In 1903, this handsome red-brick house at 622 North Twenty-ninth Street was considered out of town. The house, then known as the Castle, was built by Austin North, early-day real estate man and banker. The house was designed after millionaire Potter Palmer's Chicago mansion, a European castle replica. In 1906, North sold the house to a leading stockman of Roundup, A. B. LaMott. Dr. William R. and Deda Morrison also owned the home for about 48 years.

The 1905 St. Luke's Episcopal Church is located at 3224 Second Avenue North. The Episcopal church founded a small congregation in 1883 with services held in several locations until a permanent one could be built. Many additions have been built over the years, but the little church still looks much the same as it did in 1905. (WH.)

In 1885, Rev. J. P. Halton rented a frame building on Montana Avenue and Twenty-sixth Street for $50 a year. This served as the first Catholic church in Billings until 1887, when the first permanent structure was built. St. Joachim's was erected at First Avenue North and Thirty-third Street. The Catholic population outgrew the small church early in the 1900s. St. Patrick's Co-Cathedral was built in 1906 at a total cost of $100,000. The church is of Old English Gothic design. The bishop spared no expense in detailing the beautiful interior of the church. Here is a partial list of interior costs to decorate the church: ornamental plastering $6,500, interior decorating $2,700, art glass windows $6,300, furniture $3,800, Stations of the Cross $2,600, and statuary $1,860. In the 1930s, the interior was redecorated in the art deco style. The postcard below shows what the original interior looked like in 1910. (Left, WAI; below, JLRC.)

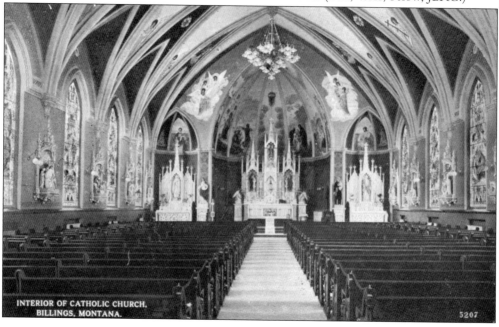

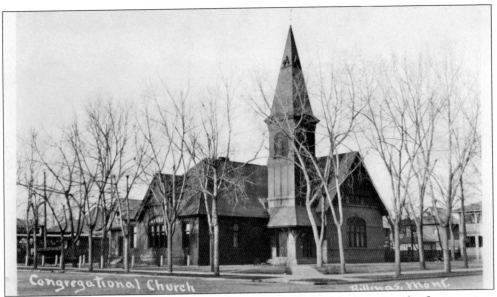

The First Congregational Church, which had roots with the Pilgrims, was the first to set up shop in Billings and was known as the city's mother church. Rev. B. F. Shuart (1850–1930) began to organize the church in 1882. In 1883, the Congregational church was dedicated at the corner of the Third Avenue North and North Twenty-seventh Street. The church received a $10,000 donation and land from the Frederick Billings family. In 1957, the original church was torn down to make way for a new church; only the steeple was reused at the Mayflower Church. (CC.)

In 1903, the First Presbyterian Church was organized in the Labor Union Hall over Peter Yegen's harness shop on Minnesota Avenue. Over the next two years, the church moved several more times, ending up in a building on First Avenue South and Twenty-ninth Street for the next 11 years. The postcard shows the third building constructed in 1917 at 3319 Third Avenue North. After 38 years, the church moved one last time to its present location at 2420 Thirteenth Street West.

The purpose of the First Church of Christ, Scientist in Billings is to restore primitive Christianity and its lost element of healing and has been an active part of Billings since 1893. Services and Sunday school have been held in the 1914 church at Division Street and Burlington Avenue. A Christian Science reading room has been maintained since 1902.

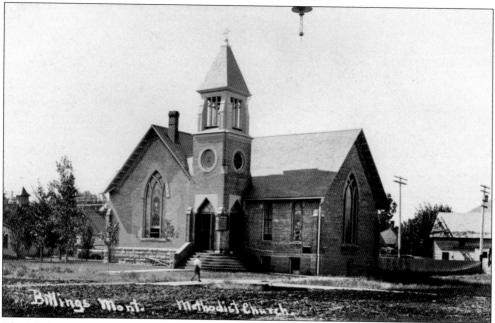

The Methodist Episcopal Church in Billings was founded in 1882 by W. W. Van Orsdall and Rev. F. A. Rossen. By 1884, the church was finally organized and plans were made to build a brick church on the corner of Twenty-eighth and Fourth Avenue North. The 1908 postcard shows the church after it had been remodeled and enlarged. Eventually the old brick church was torn down in 1964 to make way for the present structure.

Nine

PERSONALITIES, MISCELLANEOUS

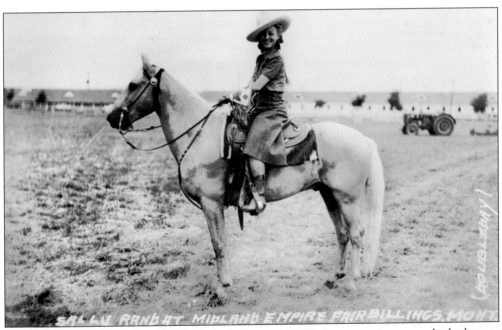

Sally Rand (Helen Gould Beck) was born in January 1904. As a young woman, she had many jobs: circus performer, actress, and dancer. Sally eventually came up with a secret formula to success—the exotic burlesque fan dance and later the bubble dance. The postcard shows Sally Rand in 1941 at the Midland Empire Fair, where she was booked to appear at the fair's Western night show. She also led the grand entry into the rodeo arena. In January 1942, Sally Rand married Red Lodge's famed rodeo star Turk Greenough. They went their separate ways after a few years. (RD.)

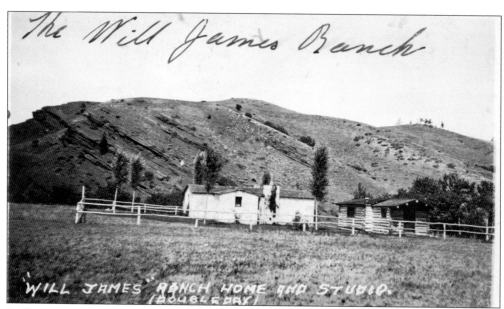

The Will James Ranch

WILL JAMES' RANCH HOME AND STUDIO. (DOUBLEDAY)

Will James (Ernest DuFault) was born in 1892. The Canadian-born James left his home at the young age of 15 and traveled west to follow his dream of becoming a cowboy. He eventually settled, for a short while, on a ranch near Great Falls. Handling wild horses occupied his days and became the basis for many of his books and drawings. He was practicing and refining his drawing technique. Even though he was still a young man, he had to find an easier occupation than rodeo bronc riding. He wrote several short stories for Scribners, which eventually led to 24 full-length books. In James's short 50 years of life, he wrote 24 books and illustrated each one himself. His best-known story was *Smoky*, which won the Newberry Award in 1927 and was made into a movie. In 1927, James bought an 8,000-acre ranch south of Billings named the Rocking R Ranch. The above postcard is a view of the Rocking R Ranch house with his log studio to the right. The card below is a view of Will James's cowboys on the ranch. He eventually sold the ranch and moved to his Billings home at 3106 Smokey Lane. (Both, RD.)

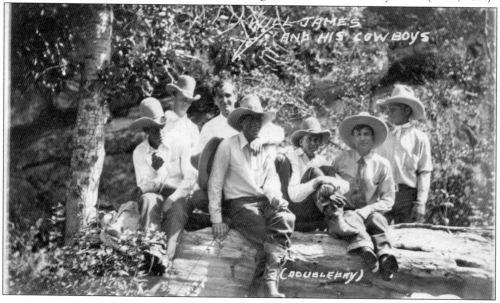

WILL JAMES AND HIS COWBOYS (DOUBLEDAY)

In 1906, James Webb was elected sheriff of Yellowstone County. On March 24, 1908, Sheriff Webb was shot dead by William C. Brickford, a Wyoming horse rustler, at the Woolfolk and Richardson ranch near Roundup, Montana. The next day, Brickford was hunted down by several posses and was killed in a wagon shoot-out. He is buried at Mountain View Cemetery at the bottom of the hill in an unmarked grave. Sheriff Webb, on the other hand, was buried at the same cemetery with much fanfare. The postcard at right shows James T. Webb in a rare posed death photograph to memorialize his dedication and service. The photograph below is of Webb's grave site. His faithful horse did not want to leave his side. A nice grave marker was added later. The citizens of Billings raised money for a drinking fountain memorial on the corner of the courthouse lawn to honor Sheriff Webb. (Below, MPC.)

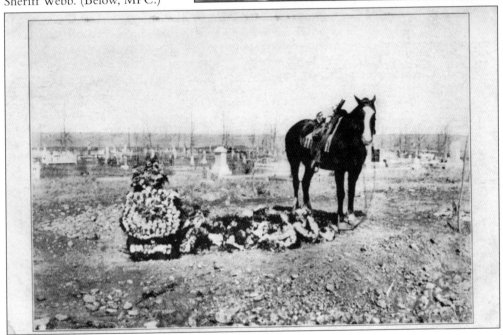

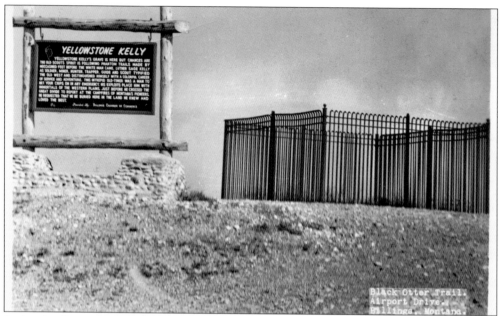

Luther "Yellowstone" Kelly (1849–1928) came to Montana via New York in 1868 after serving in the Civil War. He began hunting and trapping along the Yellowstone River. Kelly also served as chief scout for several generals during the Indian Wars from 1873 to 1878. He retired in California, where he died in 1928. At his request, he was buried at the summit of Kelly Mountain overlooking Billings, the land he loved. (KFR.)

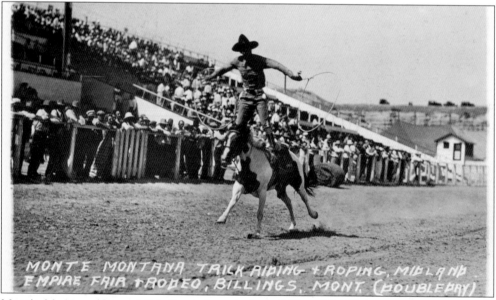

Montie Montana (Owen Mickel) was born in June 1910 at Wolf Point, Montana. He was a trick rider and a master trick roping artist. Montie appeared in several John Wayne movies and was a fixture on the rodeo circuit. He also rode his horse in 60 Tournament of Roses parades, waving to the crowds from a silver saddle. He died at the age of 88 in Los Angeles, California. The postcard shows Montie Montana trick riding and roping in front of a large crowd at the Midland Empire Rodeo.

On the morning of October 5, 1918, former president Theodore Roosevelt rolled into Billings on an eastbound train. He was on a promotional trip through the West to help county governments come up with their subscribed allotment in selling liberty war bonds, used to help fund the war effort. When Roosevelt arrived, he was surprised that Yellowstone County had already raised several thousand dollars over their allotment. While in Billings, he gave eight speeches in 10 hours and shook hundreds of hands. Roosevelt also toured the city and was the honored guest at breakfast, lunch, and dinner. He had a speech at the auditorium fairgrounds with over 7,500 people in attendance. After Roosevelt left Billings, he traveled to his home state of New York, where he died three months later. The postcard at right shows Teddy Roosevelt at the downtown band concert put on by A. M. C. band with local dignitaries at his side. The card below shows Roosevelt shaking hands at a cowboy mess supper tent. (Both, MFS.)

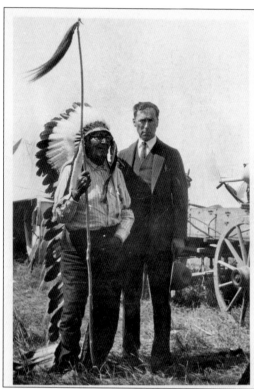

This photograph shows William ("Bill") Hart and Chief Plenty Coups (a Crow Indian chief) on top of the Rims on July 3, 1927. After talking for several hours about the Old West, the two became very good friends. Chief Plenty Coups was in Billings to help celebrate the city's 45th anniversary (and judge the Native American dancing) during the three-day celebration.

William S. Hart (1864–1946) was a successful Broadway actor who was fascinated by the Old West. In 1914, he started to play silent Western movie roles, which were noted for their realistic portrayals of the Old West. The postcard shows the Yellowstone Range Rider statue, which William Hart dedicated on July 4, 1927. He modeled the statue after himself and his favorite horse, Fritz. Hart paid $20,000 out of his own pocket for the 6-foot, 7.5-inch tall bronze sculpture. (KFR.)

In 1927, William Hart dedicated a full-size bronze statue of himself and his horse. It was originally located about three-quarters of a mile to the east, overlooking the Rims from where it currently stands in front of the airport. Shortly after it was dedicated, someone stole the spurs off the statue.

On June 2, 1939, Olave V, prince of Norway, and Martha of Sweden stopped in Billings on a grand tour of the United States to help cement relationships between the two countries. The postcard shows the crown prince and his wife on the balcony of the Northern Hotel. She is wearing the large black-and-white print dress. (KFR.)

On the reverse, this 1915 postcard has an advertising calendar for the Sanitary Food Shop, located in the Masonic Temple building on Third Avenue North and Broadway. Its policy is "dictated and directed by your demands. It will grow and become great only by pleasing you. How well we have chosen for you and how moderately we have priced is a tale that tells itself in our merchandise. Buy here and you buy well." The Sanitary Food Shop was open for less than 10 years.

Did You Buy Your Groceries From Us Last Month?

	1915			MARCH		1915	
	SUN	MON	TUES	WED	THUR	FRI	SAT
"Broadway"	-	1	2	3	4	5	6
Brand	7	8	9	10	11	12	13
Coffee	14	15	16	17	18	19	20
	21	22	23	24	25	26	27
	28	29	30	31	-	-	-

"Wonder" Brand Coffee

The Sanitary Food Shop

Masonic Temple Corner BILLINGS

This 1910 advertising postcard is for P. B. Moss's First National Bank, located at 2701 Montana Avenue. He moved to Billings in 1892 in the hopes of buying into a bank. By 1894, he was president of his own bank. After an 1893 financial panic and run on the bank, P. B. Moss was able to keep the bank open with its last $50 while other banks failed. The First National Bank finally fell into receivership in 1912.

David Roe used this 1911 calendar postcard as an advertising promotion. Cards were given to customers each month when they shopped at the David Roe Dry Goods Company. David opened his store in 1910; it was located at 2817 Montana Avenue opposite the Western Heritage Center. He was in business for only about 10 years.

In 1917, a traveling photographer took this photograph in a Billings neighborhood. The photographer would advertise in the local papers that he would be in a town on a certain date and that any child could have their picture taken in a goat cart. Similar goat cards have been seen throughout Montana.

On June 12, 1937, Billings experienced the worst flooding in its history. Rain and hail swept through the Yellowstone Valley. At one point, a cloudburst of over 2 inches of rain fell in a single hour, causing Canyon Creek and Alkali Creek to overflow. This overflow sent large amounts of water toward Billings. Rainwater runoff washed large boulders off the Rims and closed North Twenty-seventh Street to the airport. Another problem was that the Big Ditch broke near the Highlands Golf Club near Poly Drive and Virginia Lane. The floodwater flowed through Pioneer Park and into downtown Billings. During the highest part of the floodwater, it reached 28 inches in downtown Billings, filling basements and stranding motorists. Several residents used boats to get around downtown Billings. Most of the south side of Billings received little flooding because the railroad tracks acted as a dyke. The above postcard was taken on Broadway and First Avenue North. The Northern Hotel can be seen on the right. Cars left wakes behind them while driving on flooded streets. The card below shows the Grand Hotel on Twenty-seventh Street with floodwaters reaching car bumpers. (Above, FEC.)

BIBLIOGRAPHY

Billings Gazette. Various issue and articles, many from clippings files, Montana Room, Parmly Billings Library.

Boden, Anneke-Jan. *Billings: The First 100 Years.* Norfolk, VA: Donning, 1981.

Cooper, Myrtie E. *From Tent Town to City: A Chronological History of Billings, Montana 1882–1935.* Billings, MT: Parmly Billings Library, 1981.

Dawson, Patrick. *Mr. Rodeo: The Big Bronc Years of Leo Cremer.* Livingston, MT: Cayuse Press, 1986.

Jensen, Joyce. *Pieces and Places of Billings History.* Billings, MT: Western Heritage Press, 1994.

Polk, R. L. *Billings City Directory.* Salt Lake City, UT. Various years.

Stevens, Karen, and DeeAnn Redman. *Billings A to Z.* Billings, MT: The Friends of the Library, 2000.

West, Carroll Van. *Images of Billings, A Photographic History.* Billings, MT: Western Heritage Press, 1990.

Wright, Kathryn. *Billings: The Magic City and How It Grew.* Billings, MT: Reporter Printing and Supply Company, 1953.

———. *Historic Homes of Billings.* Helena, MT: Falcon Press, 1981.

Discover Thousands of Local History Books
Featuring Millions of Vintage Images

Arcadia Publishing, the leading local history publisher in the United States, is committed to making history accessible and meaningful through publishing books that celebrate and preserve the heritage of America's people and places.

Find more books like this at
www.arcadiapublishing.com

Search for your hometown history, your old stomping grounds, and even your favorite sports team.

Consistent with our mission to preserve history on a local level, this book was printed in South Carolina on American-made paper and manufactured entirely in the United States. Products carrying the accredited Forest Stewardship Council (FSC) label are printed on 100 percent FSC-certified paper.

MADE IN THE USA